THE CORONATION OF NAPOLEON PAINTED BY DAVID

In memory of Antoine Schnapper
S. L.

THE CORONATION OF NAPOLEON

painted by David

Sylvain Laveissière

With the collaboration of
David Chanteranne
Anne Dion-Tenenbaum
Alain Pougetoux
Mark Tucker
John Zarobell

Photographs by
Erich Lessing

Paris
Musée du Louvre
19 October 2004–21 January 2005

Musée du Louvre

HENRI LOYRETTE
Chairman and Director

DIDIER SELLES
Chief Executive Director

ALINE SYLLA
Deputy Executive Director,
Director of Cultural Development

FOREWORD

This text is adapted from an essay published in French in the last part
of the book by Sylvain Laveissière, *Le Sacre de Napoléon peint par David*,
for the exhibition with the same title, Paris, Musée du Louvre,
21 October 2004–17 January 2005 (co-edition Musée du Louvre Editions–5 Continents).
The most complete study of David's works is Antoine Schnapper, *Jacques-Louis David,
1748–1825*, catalogue of the exhibition, Paris, Musée du Louvre, and Versailles,
Musée national du château, 26 October 1989–12 February 1990, Paris, 1989.

This exhibition was organised by the Musée
du Louvre. It was designed and mounted
by the Architecture, Museography and
Technical Direction of the Musée du Louvre,
Philippe Maffre and Philippe Compans.
The project was coordinated in the
Exhibitions Division of the Direction of
Cultural Development by Soraya Karkache,
departmental head, and Nicole Chanchorle,
for the handling of the works.

The Fondation Napoléon is in partnership
with the Musée du Louvre for the
bicentennial of Napoleon's Sacre.

FONDATION NAPOLÉON

The exhibition was sponsored by Chaumet.

CHAUMET
PARIS

Curator of the Exhibition
SYLVAIN LAVEISSIÈRE
Chief Curator at the département des Peintures, musée du Louvre

With contributions of

DAVID CHANTERANNE
Historian, Secretary-General of the magazine Napoléon Ier

ANNE DION-TENENBAUM
Curator at the département des Objets d'art, musée du Louvre

ALAIN POUGETOUX
Curator at the châteaux de Malmaison and Bois-Préau

MARK TUCKER
Vice Chairman of Conservation and Senior Conservator of Paintings
at the Philadelphia Museum of Art

JOHN ZAROBELL
Assistant Curator of European Painting and Sculpture before 1900
at the Philadelphia Museum of Art

Photographs of David's painting
ERICH LESSING

Publication by the Editions
department of the Direction
of Cultural Development
under the directorship of
Violaine Bouvet-Lanselle.

For the musée du Louvre

Editiorial coordinator
Violaine Bouvet-Lanselle,
assisted by Moïna Lefébure

Iconographic research
Moïna Lefébure
Catherine Dupont
Carole Nicolas

For 5 Continents Editions

Editiorial coordinator
Paola Gallerani

Translation
Susan Wise

Editing
Fronia W. Simpson

Graphic Design and Layout
Lara Gariboldi

Colour Separation
Cross Media Network s.r.l., Milan

Printed September 2004
by Leva Arti Grafiche,
Sesto San Giovanni, Milan
for 5 Continents Editions, Milan, Italy

www.louvre.fr
info@5continentseditions.com

© Musée du Louvre, Paris, 2004
© 5 Continents Editions s.r.l., Milan, 2004

ISBN Musée du Louvre: 2-901785-96-4
ISBN 5 Continents Editions: 88-7439-128-5

Contents

We can stroll around in this painting…

… ce n'est pas de la peinture, on marche dans ce tableau …
Napoleon to David, 4 January 1808

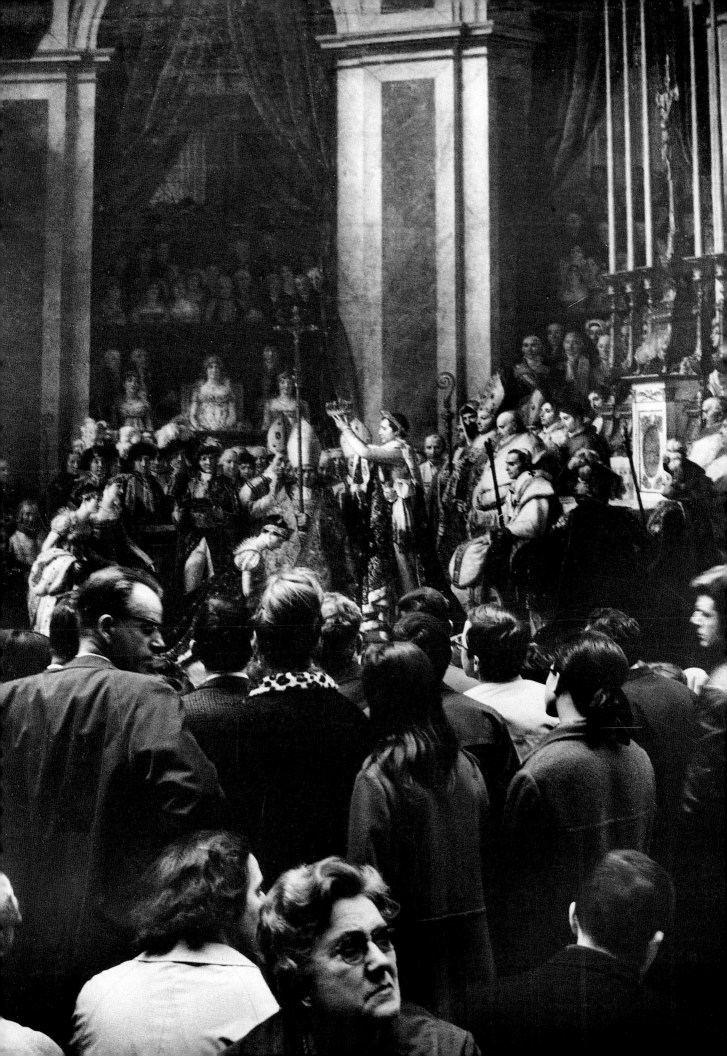

INTRODUCTION

Le Sacre (The Anointing): we know this title is inappropriate. The real title of the painting is the one printed in the booklet of the Salon of 1808: *Le Couronnement (The Coronation)*. So is it Napoleon's coronation? Wrong again: Josephine is being crowned by Napoleon. So what should we call this painting? *Coronation of the Emperor Napoleon and the Empress Josephine at Notre-Dame de Paris on 2 December 1804*—or *The Anointing of the Emperor Napoleon and the Coronation of the Empress Josephine* … which is rather long? Popular opinion chose the incorrect, but short, title: *Le Sacre*, so that is the one we shall use.[1]

Is it the largest painting in the Louvre? David believed it was, but the *The Marriage at Cana* by Veronese, that he thought he had surpassed, is bigger.[2] However, the *Sacre* is more famous. Does it owe its fame to its subject, its hero, rather than to the painting? We doubt it. Napoleon is indeed the most renowned historical figure of our era: a work of art focused on him benefits by a surplus of celebrity at the outset. Yet to become popular a painting must prove equal to its subject matter.

One of Napoleon's strokes of good luck was to have met David. He did not turn him into a fawning painter, prone to flattery, but offered him the greatest challenge of his career as an artist already at the height of his success: an impossible subject. The test lay in this very combination of art and power, and that is what makes the work interesting to study: the two cannot be separated. Without an authoritarian power, there is no painting of the *Sacre*. But without a supremely talented painter, there is no event.

The pitfalls lay in emphasising pomp and ceremony and reducing the actors to walk-ons, waxwork dummies, or, by contrast, in staking everything on the accuracy of the portraits and the action, thus depriving of its solemnity an event that demanded a great deal of it not to appear a masquerade.

David was famous for painting oath-taking: antique, that of the Horatii (1784), is his first triumph; modern, that of the deputies assembled in the Jeu de Paume (1791), was never painted, no more than the one of Napoleon at Notre-Dame (1804), that never went further than the sketch stage. The oath of the army to its emperor on the occasion of the distribution of the eagle standards (1808–10; Musée de Versailles) is the only one he executed before going back to the antique: Leonidas and his Spartans vowing to be sacrificed so that Greece might be saved.

The *Sacre*, in the series of four paintings meant to commemorate the coronation celebrations, is the *religious* picture. It is a mistake to underestimate in this painting the role of the pope, who is frequently reduced by modern commentators to that of a passive witness. This figure, the brightest one in the composition (haloed by Cardinal Caprara's ermine that enhances its whiteness), vividly embodies spiritual power. David would regret that at the last moment the emperor forced him to paint the gesture of blessing that, in introducing movement, reduced the image of the concentration of the pontiff, who is present as the representative of God on Earth. What is true is that despite the numerous and brilliant clergy, whose garb contributes greatly to the gorgeousness of the painting, and even despite the presence of the pope, the cult being celebrated is that of personality.

Whoever takes an interest in this painting soon finds out it is not, despite the artist's claim, a faithful account of the ceremony. The example of Madame Mère—overlooking the scene from her box although she was in Rome the day of the coronation—gives an idea of the liberties the painter took with history. We also are aware that the depicted subject, the coronation of the empress, had been preceded by that of the emperor himself, and we can even find traces proving it. The change is highly significant: the haughty autocrat, claiming to owe his authority only to his sword, pressed to his breast, has become a "French knight" delicately crowning his deeply moved companion. It is instrumental as well, since it gives the painting its unity, its rhythm, its temporal dimension. However, before making this modification, David admitted he would "regret" his first figure: bold and excessive (therefore out of place for a courtier like Gérard, his former pupil who suggested the new gesture) but whose heroic gesture connected this painting to the rest of his work, from the *Horatii* to the *Jeu de Paume*... Among present-day interpreters of the *Sacre*, some still criticise the artist for this conversion. David's comment to Gérard proves it was not performed without some misgivings.

While these discussions have their importance, they should not make us overlook the painting, something David never does. To the critic Boutard, he confides that in the subject he found "more resources for art than he had expected". And when he writes to Degotti—an artist friend, this time: "I absolutely have to alter the head of the crucifer, the more beautiful the cope becomes the more ridiculous the head is, as a friend you must give me a proof of your obligingness, you must pose the head for me and I shall do it myself"—we feel a kind of delight at the thought of completing the wonderful piece of painting of the crucifer's [55] cope—the one against which Josephine's profile clearly stands out!—by executing *himself* the handsome head of the dark-eyed Italian, the scene painter of the Opéra whose expression is unforgettable.

So this painting, so famous it is almost a myth, draws millions of visitors to the Louvre every year: come to see Napoleon, they leave with an ineffaceable vision of a painting that is more the creation of the event than its reproduction.

Just like monuments and museums, there are paintings you go and visit. *The Coronation of Napoleon* painted by David deserves more than any other to be entered, to be visited. Napoleon himself is the one who invites us, exclaiming as he did on seeing the painting: "It is not a painting, we can stroll around in this picture."

The purpose of this guide is to escort the visitor inside this famous painting, to examine all its details including the dimmest boxes: we shall discover that David portrayed himself in the act of drawing the scene and placed there several of his colleagues and artist or scholar friends.

Of course this painting was designed to assert the legitimacy of a personality such as there have been but few in history, and one who soon would be faced with a coalition of European countries. It is at once a ceremony—with its rite, its actors, its dazzling costumes—and a celebration of painting, in which a great artist, famed for his antique subjects, challenges a field that is utterly new to him with a success that two centuries have not belied.

To help find your way in this huge, complicated composition, all the figures have been given a number to allow us to locate them quickly. Of 146 delineated physiognomies, almost half have been identified, and we hope the future will bring new discoveries, made easier by this publication.

Jacques-Louis David (1748–1825)
Sacre of the Emperor Napoleon I and Coronation of the Empress Josephine
in the Cathedral Notre-Dame de Paris, 2 December 1804
Canvas. 6.21 x 9.79 m
Signed lower right: *L. David.f.ebat*.
Dated lower left: *1806. & 1807*[3]
Commissioned by Napoleon I in October 1804;
painted from 21 December 1805 to March 1808
Paris, Musée du Louvre, département des Peintures (INV. 3699)

Exhibitions
1808, Paris, Musée Napoléon, 7 February–21 March
(see *Description ...* and *Nouvelle description ...* , 1808);
1808, Paris, Musée Napoléon, 14 October 1808–January 1809,
Salon of 1808, no. 144: *Le Couronnement*;
1810, Paris, Musée Napoléon, 25 August–October, Concours décennal;
1889, Paris, Palais des Champs-Elysées, *Exposition centennale* (1789–1889), no. 237;
1948, Paris, Musée du Louvre, *David*, no. M. L. 60;
1989–90, Paris-Versailles, *David*, no. 169 (catalogue by A. Schnapper).

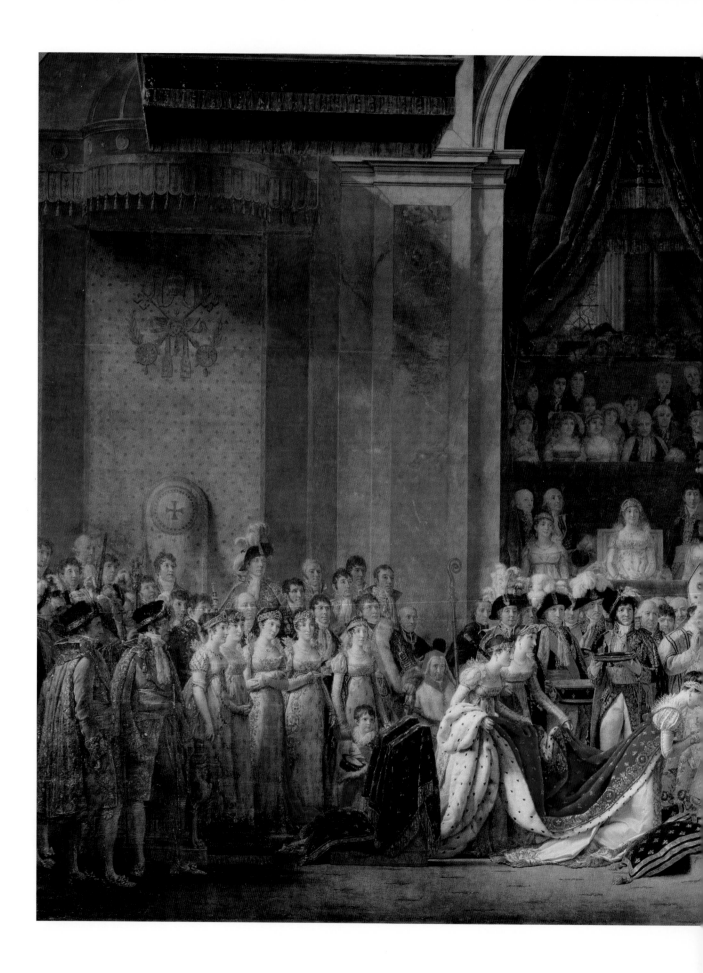

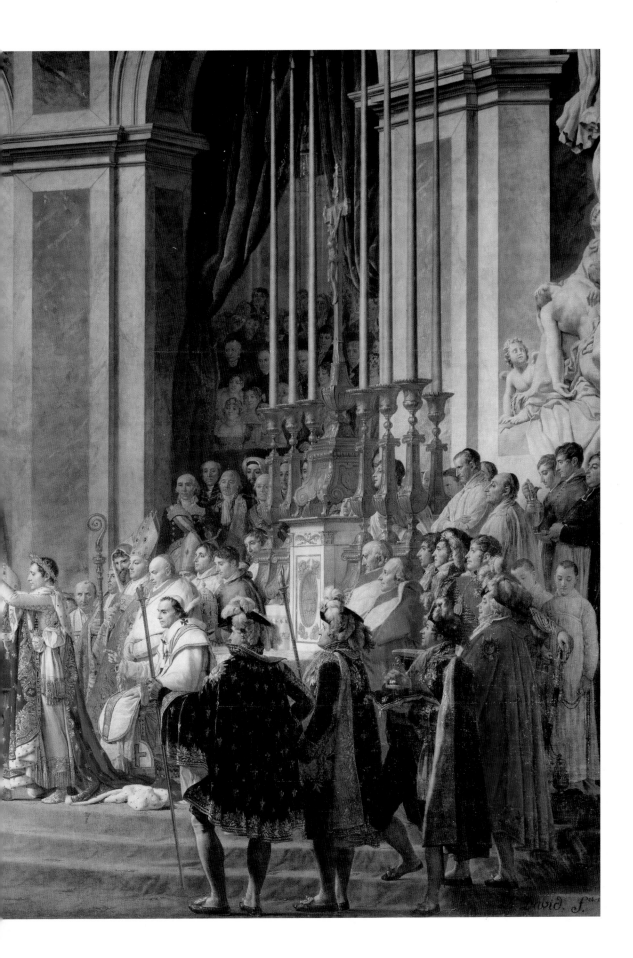

In the Salle Daru of the Musée du Louvre, devoted to French painting of the Neoclassical period, on busy days the crowd thronging in front of the painting sometimes seems to be a part of it, merging with the painted figures. This impression, that David noticed as soon as the public was admitted to see the work in 1808, and that Boilly rendered in an admirable small painting, still strikes us today. The photographer Willy Ronis did not miss it and in 1968 captured in an image soon to become popular the osmosis between the painted spectators and the live ones (p. 8). The crowd effect created by the painting, the life-size scale of the figures, and above all the veracity of the light and the realism of the portraits contribute to this illusion.

It is not surprising David staked the success of his painting on its realism: a prestigious subject, accurately represented, can but produce a prestigious painting. This age-old sophism, that reduces art to the passive imitation of reality, does not delude the artist, but he is aware of its efficacy and repeats descriptions of the painting, claiming that seeing it is like attending the ceremony itself. Since the public actually present at Notre-Dame on 2 December 1804 was very select, the assertion of authenticity, published in the press, naturally appealed to the greater number, always eager to see celebrities.

Yet more than anyone else, David knew his painting offered of the event an image that had been entirely recomposed: not a document for archives, but an image for history.

We already mentioned the most famous of these "compromises" with the historical truth: the presence in a box right at the centre of the painting of Madame Mère, Letizia, who was known to have been in Rome that day to mark her disapproval of Josephine's coronation.

2 December 1804

The historic anointing had taken place on 2 December 1804. Napoleon Bonaparte, First Consul since the coup d'état of 18 Brumaire (9 November 1799) that had put an end to the Directory, had been proclaimed "Emperor of the French" on 18 May of that same year [61]. He immediately appointed eighteen *maréchaux* and established a court, with titles of princes for his brothers, sisters, and high dignitaries like Talleyrand [95]. The new monarchy having been declared hereditary, Napoleon became the founder of a dynasty: all he needed was the consecration of the religious authority to enjoy a legitimacy that would make him like the other European monarchs. After the Concordat (15 July 1801) whereby France made peace with the Roman Church, Napoleon's uncle, Cardinal Fesch [85] negotiated with the papal legate, Cardinal Caprara [71], for Pius VII [72] to go to France to perform the anointing of Napoleon.

At the same time, Napoleon had no intention of appearing to be subject to this authority. He arranged for the pope merely to anoint him, which took place during the ceremony of the unction, but not to crown him: that he would do himself.

This arrangement had been previously agreed with the pope, but it did not appear in the ceremonial printed before the coronation, so many believed it was an improvised gesture that had supposedly dismayed the pope. That is not the case. Napoleon grasped the laurel wreath of gold, donned it, then took up Josephine's crown, that he held aloft before placing it on the head of his kneeling spouse.

The Moment of the Painting

These two episodes took place in sequence, and David made several drawings studying each of the two actions. However, he chose to represent the first, even giving it a highly dramatic movement: Napoleon, arched backward, holds in his right hand the gold wreath above his head,

while grasping with his left hand the hilt of his sword. This is how David describes the scene in the account he sent to Intendant Daru on 19 June 1806: "His Majesty, risen to the altar, grasps the crown, with his right hand puts it on his head while with his left hand he presses his sword to his heart; this grandiose movement reminds the astonished onlookers of this well-known truth: that he who was able to win it [the crown] will also be able to defend it. The attitude, the gesture, the eyes of the awestruck crowd, everything is focused on the sense of admiration shared by all. The kneeling empress, at the foot of the altar, hands joined, awaits the crown her august spouse will place on her head."

That is the action we can see in the three compositional drawings (the first preserved in a private collection, the second at the Musée du Louvre, the third, dated 1805, at the Fondation Napoléon), in which David arranges the composition of the *Sacre*, as in the recently identified painted oil sketch found under a painting on a wooden panel by David, *Pius VII and Cardinal Caprara* at the Philadelphia Museum of Art.[4] It is the same if we closely examine the final painting: behind Napoleon's bust we now see, we can make out the raised head wearing the laurel wreath and over it the crown held aloft by the emperor. These are the traces of the earlier figure that had been painted, then scraped off, and that now resurfaces. This confirms the documents of the period that claim that David had really painted what he had planned on the large canvas before altering his course. Supposedly the idea of this change was suggested to him by his former pupil Gérard, who had become the portraitist of the new imperial society. As for Napoleon, according to the grand *maréchal* Bertrand, he made this statement at Sainte-Hélène on 26 January 1821: "In the painting of the coronation, what we see is actually the coronation of the Empress, and not mine: it was a little scheme between Josephine and David, with the pretext that it would make a prettier painting. Josephine, who feared divorce, thought she had won something by this little device. Some remarked the painting was not appropriate; that it was the Emperor's coronation that should have been represented. I paid no attention and let him paint 'the prettier picture'".

This modification gives the painting a radically different meaning. The military chief, decked out in the imperial dignity of the Caesars and proudly claiming that his power derives from himself alone—this before the pope, the representative of God on Earth—has become a "French knight" (Napoleon coined the expression) who, in a spectacular gesture, yet not without a certain gentleness, shares his new dignity with his spouse. "It will be more gallant, the Empress will attract more interest, and the Emperor as well, since he will not seem to be thinking only of himself", commented David.

While bestowing a more human image on Napoleon, David ensured the unity of his composition by creating a physical bond between the two main actors. But the painter of the *Oath of the Horatii* (1784, Musée du Louvre) confessed he would regret the first idea, this bold gesture of the autocrat, this tension of the great theatrical movement that probably portrayed Napoleon's true nature more accurately. He was not the only one: at court, the Bonaparte clan, Napoleon's brothers and sisters, despised Josephine and were furious to see her thus glorified. The former revolutionaries, like David, rallied around Napoleon, preferring to see him as a charismatic hero rather than as the successor to a monarchy they had overthrown.

In its new position, the crown is still the focal point of all eyes: the artist did not have to alter the expression of the spectators who appear to be holding their breath during this solemn moment.

David had turned Caesar *imperator* into the knight Bayard: nonetheless, he wished to leave a symbolic trace of his first idea. He filled the place of the arched torso of the first Napoleon, become vacant when his body was straightened, with a figure of an Italian priest [66] with a balding pate. But the head is not the portrait of a member of the clergy accompanying the pope; it is Julius Caesar's! In a sketchbook for the painting, David drew from two angles an antique bust of Caesar that he used as a model for this head. Forced by circumstances to alter his subject, David inscribed this austere, emblematic figure into the painting as a vivid recollection of the sacrifice he had made.

Once he altered his course, David presented the sequence of actions like a dynamic principle, in a composition threatened by stasis—and for which, even altered, it would be criticised. The *Affiches, Annonces et Avis divers* of 7 December 1807 published a first description in which we can observe David's urge to ward off criticism: "The main action the painter rendered is the coronation of Her Majesty the Empress by her august spouse", but "imagination [...] can grasp two paintings at once". The viewer has the impression of being there ... with a disturbing precision: "The Emperor [...] has his left foot raised: we see him going down the first step of the altar". We wonder if the writer—probably an acquaintance of David, as was Lenoir—did not have in mind one of the drawings where that pose is envisaged. In the painting, Napoleon's two feet are on the same level, and it is materially impossible for him to crown Josephine without going down a step. David preferred not to initiate a movement that would have compromised the balance of the ensemble by destabilising his pivotal figure.

"The *Coronation*: that is the name of this painting, given by the artist. Producing it under this indefinite title, M. David stresses his intention to offer in a single action the two main circumstances of this memorable ceremony. He chose the moment when His Majesty the Emperor and King, who has just himself placed on his brow the two crowns, removes one and is about to put it on the head of his august spouse".[5] By merely altering the gesture of a figure—but what a figure!—David changed the entire dynamic of the painting. Before, each half appeared to be separate. Now, it all flows together. The composition found its balance in finding its final movement.

THE SITTINGS

The emperor, the empress and the pope were the only personalities who did not come to pose in David's studio; but all the court did. It must have been at the palace that David drew Josephine and Madame Mère [105] whose full-length sketch is annotated "from life". If she does not appear in any of the compositional sketches, the last of which is dated 1805, David mentions her in his 19 June 1806 report: "Her Imperial Highness, Madame, in a separate box, with the appropriate retinue, attends an event as glorious as it is touching for a mother's heart". Done on orders of the emperor, as David was to confirm in 1822.[6]

Rouget, David's "right hand" in painting the large canvas, jokingly reports to us the repeated tardiness of the duc de Cossé-Brissac [104] and the impatience of David, "Premier Peintre of the Emperor", forced to wait, palette in hand, for "M. le Duc *de* Cossé *de* Brissac, and *de* what else?"

We have several letters from David to models asking them to come to his studio. There are various instances, from the head (or less), for which he requires two hours, to the full-length portrait.

On 22 January 1806 David returns his garb to Louis Bonaparte [12], but we do not know when the future king of Holland came to pose for the face. On 25 March, David writes Degotti: "I absolutely have to change the face of the figure of the crucifer [...]. You know that it will take about two hours, and besides you enjoy coming to the studio". Whatever the name of the crucifer of 2 December may have been (apparently the cardinal de Bayane), we now know that his face was painted after that of the scene painter from the Opéra ...

On 26 May David asks Talleyrand to send him the entire costume he wore on the day of the coronation, and on 30 July he wishes him to come in person: "shortly I shall request of Your Highness a few hours to paint the head of the figure that represents you. The clothing is already done".

He wrote on 20 August to Cardinal Fesch [85], beseeching him to come to his studio at Cluny and to grant him "a couple of hours of your obligingness so that I can put your likeness in it".

On the 26th the cardinal asks him to postpone the sitting, and on 21 September David writes him: "I received the letter whereby you inform me that Tuesday [23 September] at [*corrected*: around] 8 o'clock, is the day you have set for the sitting, I am entirely at Your Eminence's orders and I shall ready myself to do a head worthy of a true connoisseur of painting": we know the cardinal was the keenest collector of painting of his time.

The sittings continued in 1807: on 4 March David visits the sculptor Jean-Guillaume Moitte [118], invites him to come and see the picture and pose for him the next day. We know by the letter to Beugnot of 23 May that at this date in the large painting you could see, with the imperial couple in its definitive form, the portraits of M. de Viry [5], the lady-in-waiting and the tirewoman [34, 36], the pope [72], Prince Eugène [93] and the choirboy who is admiring his sabre [100].

On 3 July David writes to Metternich, the Austrian ambassador to Paris, for information concerning his predecessor, comte Cobenzl [153], whom he has to portray in *The Coronation*, asking about "his features, his garb, and the orders with which he is decorated, or else lend me one of his portraits if I have the good fortune of such an advantage". He invites him to come and see his painting. So we know that the group of ambassadors to which the portrait of Cobenzl belongs was not completed until 1807: among the figures in the "pits", he is the one farthest back. Like Madame Mère (angry), the legate cardinal Caprara (indisposed), and the Turkish ambassador (Moslem), Cobenzl did not attend the *Sacre* at Notre-Dame, but in his case it was for diplomatic reasons (Napoleon had recently claimed precedence over his master the emperor of Austria, Franz Josef II). His forced presence in the picture takes on an even deeper political significance.

The last to come to sit also occupy the places farthest back: an undated letter to the comte de Bausset [23] informs us that David was to paint on the following Monday M. de Beaumont [26] and "Tuesday or Wednesday" Bausset himself. In fact a second letter to the latter dated 8 December 1807 says: "I expect you this morning at eleven, we must get this done as soon as possible, because the public that has started to come in throngs would keep us from working if we further delayed. Do not forget to have your chamberlain garb brought: you can come to the studio in informal dress, yet with your hair done, unless you would rather come dressed if you must go somewhere else afterward. As for the flattering words you are so kind to write me, I wish I were indeed able to confer it, this *immortality*, I would only give it, I swear, to good people like you". The last to be painted, MM. de Baumont, master of ceremonies of the ambassadors to the empress from 1804 to 1809, and de Bausset, prefect of the palace, might they also be last-minute guests, perhaps added to the picture after Josephine's visit on 28 November?

THE DATE OF THE CHANGE: AUGUST 1806?

The main question the painting raised for contemporaries was its very subject. We know that, engaged to represent the coronation of the emperor, David actually painted that of the empress. Leafing through the sketchbooks, we observe, as Antoine Schnapper pointed out, that the two possibilities were envisaged concurrently, and with all the intermediary solutions. But it is no less clear that David had firmly chosen one and even executed it on the large canvas, before deciding on the other. In view of the significance in terms of power, in particular within the Bonaparte clan and Josephine's, the honour the painting conferred on the empress by this one change in the action became a state affair. Long before the painting was shown to the public, the court and the city argued so bitterly over it that the painter repeatedly advanced justifications, until Napoleon's approval, on 4 January 1808, made the issue less political than academic. Just when did David change the subject of his composition, and who was responsible for it?

If we return to the texts that describe the action, the last stipulating that Napoleon crowns himself is the report David sent to Intendant Daru on 19 June 1806: "After the translation of the

Emperor's regalia by the Pope, *His Majesty, risen to the altar, grasps the crown, with his right hand puts it on his head while with his left hand he presses his sword to his heart*".[7]

The first to comment on the new subject, regretting it, is the councillor of state Beugnot in his letter dated 23 May 1807: "You wanted to paint the Emperor's coronation; it is that great solemn ceremony that your brush is responsible for handing down to posterity. But allow me to tell you that *you painted the coronation of the Empress*. She is the main figure in the picture; the entire interest of the scene is focused on her: the Emperor only figures as an instrument and the Pope as a witness". Just at what time, during the eleven months between these two mentions of June 1806 and May 1807, did this crucial change take place? A clue might enable us to specify it.

On 30 July 1806 David writes to Talleyrand: "Prince, the figure that represents His Majesty the Emperor [61] is entirely completed, only the crown is missing. You, Prince, are its trustee, so it is to you that I take the liberty of appealing for an item so essential for the completion of my idea in the attitude I have given the Emperor. Condescend to send it to me through your confidential secretary, I will keep it but one day, he can recover it in the evening, but in that case it should be brought to me early in the morning for it to be entirely completed in a day".

Now on 31 August David asks Talleyrand to lend him the emperor's robe. "You know about painters' minds, or better said, the haste of genius, it does not like delays. Pardon my candid way of speaking, I would not express myself this way with any one else". The very next day Talleyrand, grand chamberlain, beseeches Mgr de Belloy, cardinal archbishop of Paris, "obligingly to have the robe of His Majesty the Emperor and King entrusted to my secretary M. Osmond. The painter M. David needs it a few days for making his painting". The note, signed "Ch. Mau Talleyrand prince of Bénévent", is inscribed at the bottom, "Received this 27 September 1806. Osmond.—Returned to me this 6 October 1806".

What does this sudden request mean? If the figure of the emperor is "entirely completed" on 30 July, why does David need the robe a month later? The explanation that seems obvious is that in the meanwhile—that is, in August 1806—David had decided to redo this figure with the new attitude, that is, the one we know.

THE LARGEST PAINTING IN THE WORLD?

The first thing to strike us is the size of the painting. David believed he had painted the biggest picture in the world: "This painting is thirty feet long and nineteen feet high", David wrote in 1808. Now, he will specify in 1824, "the biggest painting known hitherto, *The Nuptials of Cana*, by Paul Veronese, only measures thirty by sixteen". Yet he was mistaken: the canvas by Veronese measures 6.77 by 9.94 metres; his, 6.21 by 9.79.

A foot more or less scarcely matters. David knows he is painting an exceptional picture and he rather likes it being also the biggest: part of the feat is the fact that the artist was sixty years old.

CONSTRUCTION

The orientation of the painting was determined by the initial plan to show Napoleon's sword: "The robe open on the left side allows the sword to be seen", says *Le Livre du Sacre*. This meant the emperor had to be facing left. In *The Eagle Standards*, he faces right; drawings for *The Reception at the Hôtel de Ville* and for *The Oath* repeat these positions. That direction of the composition, facing right, corresponds to the direction in which we read and often implies the notion of progression.

Did David use a "geometric diagram"? Louis Hautecœur points out that after having returned to "the arrangement on the diagonal not used since the *Belisarius*" (which is open to question), David "again divided this immense rectangle into extreme and mean ratios, defining a central area enclosing the Emperor and the Empress and tracing a line running exactly

through Napoleon's eyes".[8] Indeed, we observe that the "golden section" dividing the pillar behind the emperor in the middle actually runs through his left foot and, if we recall that he first had his body arched backward, we shall admit that David followed that vertical even more closely. The matching golden section, toward the left, is not emphasised. The lines of perspective converge on the left near the right edge of the high back of the pontifical throne, between the heads of Nansouty and Duroc [13, 19], and the horizon as well passes through Napoleon's eye [61].

The vertical axis of the painting goes through Josephine's forehead [52], the two white mitres and the figure of the *maréchale* Soult [107]. David skilfully avoided drawing attention to the central point of the canvas: slightly to the right and higher up is where he put the branches of the gold cross held by the crucifer [55], a fascinating personality whose figure, as we have seen, was posed by the same Degotti who constructed the picture's perspective for David.

This "central section", if it does *contain* all the essential figures of the imperial couple, does not *enclose* them, because the two imperial robes flow out of it to connect them to the rest of the composition—as to the other mortals.

Another device is created to connect the top and the bottom of the composition: it is the green curtain[9] which alone clashes with the sustained rigour of the verticals and falls obliquely out of the archway to envelop the white marble pillar. Its purpose is to provide a monochrome background against which the crown can stand out, which a pillar would not do, harshly alternating dark and light. This arrangement proceeds from the new position of the crown which, in a first state—we can still make it out—was to be silhouetted on the pink surface of the same pillar. It was invented directly on the canvas and so does not appear in the compositional drawings.

The crown is the true focal point of the picture, its central figure: the symbol of a new power, of a dynasty founded the day before, toward it all eyes are directed. Its position could not be altered too much, or else the artist would have to correct the eyes of all the closest onlookers, the ones in the left half: moving it along a diagonal descending toward the left made it possible for him to leave the eyes in their original position. A man with curly brown hair disregards orders and stares at us or, rather, stares at David; it is Estève [48], the general treasurer of the emperor's household, whom the painter thus challenges. The endless saga of David's wrangling with the administration over his remuneration for the painting assures us this aspect was not unimportant to the painter. His neighbour on the right [50] replicates his gaze, probably to make it more obvious, but we do not know who he is.

SPACE, COLOUR, LIGHT, RHYMES AND RHYTHMS

Those elements of composition belong to drawing: colour and light do not contribute any less. We are told that at the first presentation of the *Sacre*, in March 1808, a great deal of criticism had to do with the stasis of the composition and especially the uniformity of tone, as well as the lack of air, which contradicts Napoleon's judgement. Others ironised on its realism on its success: it was stifling at Notre-Dame, too…

Deeply affected by this criticism, some coming from artists, David reflected upon the harmony of his composition and corrected the tone as well as the lighting. When, in September 1808, the public rediscovered the canvas in the Salon Carré, it had the impression it was a new picture.

The point was, of course, to make the painting's message clearer, to prevent attention from straying. If everything looked grey, light should be concentrated on the protagonists and diffused on the secondary players. The eye would have no choice but to comply with the volition of the painter, orchestrator and stage director of the operatic final act.

The play of "plastic rhymes", as in poetry, is meant to add force to the composition by repeating a similar form in two separate areas, yet without producing a tiresome sense of symmetry. In the foreground there is the matching pair of Napoleon's two brothers [6, 12] on the far left and

the two ex-consuls Lebrun and Cambacérès [77, 79] toward the right: in each group, one is a three-quarter rear view, the other a profile. Notice that these four are "pretenders" to power and have been excluded. Moreover, Louis Bonaparte will shamelessly complain to the painter about the merely decorative role he is made to play (letter of 21 September 1807).

In this huge canvas, David gives greater breadth to some figures by doubling them with their near likeness in colour and form: the most striking example is that of the pope, whose figure is enhanced and lit by the cardinal legate Caprara: this explains why the painter was so determined to represent Caprara [72, 71] without his wig, contrary to the desire of the model, of whose bald pate David wrote, "the color of which promised so beautiful an effect".[10] On the right, there are the two red cardinals Pacca and Fesch and near the edge the two priests in grey, one of whom is holding a ewer; on the left, Napoleon's two brothers and two sisters; at centre, the two ladies-in-waiting. These twinned figures, scattered inside a composition swarming with people, provide solid landmarks for the eye.

In this picture, the one of the four coronation pictures devoted to religion, the presence of the Church is obviously considerable. Aside from the architectural context of Notre-Dame and the numerous clergy in the right half (we count thirty ecclesiastics), notice at each end, echoing each other, the white masses of the pontifical throne and the altar with the *Pietà* by Coustou and, on each side of the central cross, the crosier of the archbishop of Paris, Mgr de Belloy, and that of the bishop of Rome, Pius VII.

The military, to which *The Distribution of the Eagle Standards at the Champ-de-Mars* was dedicated, seems rather subdued here: there are only fourteen of its members, if we do not count as such several chamberlains and ambassadors who are officers. It is embodied in the *maréchaux*, five at centre, three on the left, one on the right, actually chosen for their role as bearers of the imperial couple's regalia and ornaments rather than for their military rank (the nine other *maréchaux de l'Empire* do not appear in the picture). More subtly, the trio of arms repeats that of the insignia of the clergy. Napoleon's sword—that was so important in the first stage of the painting, where the emperor pressed it to his breast—is framed to the left by Junot's [29] sabre, hardly noticeable amidst all the gold of the uniform but nonetheless placed above the emperor's prayer stool, and by that of Eugène de Beauharnais [93] in the shadow of the right section, where a choirboy's enthralled gaze is there to draw our attention to it. These small accessories are both amplified by the arm of their respective owners, both young (one is 33 and the other 23), both wearing a red uniform, and whose bare heads, proud and attentive, in the midst of all the plumed hats are the only truly martial attitudes in the assembly. "This half-knightly, half-heroic character is that of our modern warriors", as Beugnot writes.

These elements, although essential to the economy of the representation, for the most part were not chosen or positioned before the execution of the large canvas: the three compositional drawings include but a few, essentially the central cross (that becomes increasingly central) and, as the framing grows smaller, the balancing of the throne and the altar.

Correspondences such as these, at first invisible, subtly contribute to the overall rhythm of the picture, which in its own way is a sweeping, calm movement.

And that is David's genius: remaining true to his aesthetic conceptions while evolving and embodying the modernity of painting. Boutard, in the *Journal de l'Empire* of 25 February 1808,[11] insisted on "the majestic calmness", "the sublimity in the gentle, peaceful expression of intimate sentiments", and Beugnot admired "this composure that I call the silence of features": this requisite, defined by Winckelmann and shared by David, is certainly sought and achieved in the *Sacre*. It is not for that an immobile painting. The "stroll" Napoleon said was possible through the painting is first suggested and made possible by the blue-green rug asking to be trod upon, by the space steeped in air and light. Between the proscenium arch formed by the dignitaries against the light and the uniform grey of the boxes, that we imagine swarming with spectators (in the drawings, David has them gesticulating), the actors are distributed in groups, in bouquets one might say, that inhabit a tangible space. A procession with a lateral unfolding, indeed, but organised in depth as well: rather than superimposing

figures using a view from above, David counted on the crowd effect produced by heads placed on the same plane, as on a small scale Boilly, the painter of contemporary society, had been doing for some time.

The hanging canopy and top of the pontifical throne and the two archways open on the boxes together form a triple partition in the background that may bring to mind the more pronounced one of the three archways forming the backdrop of the *Horatii*, painted in 1784: although mitigated by the play of light, this triptych arrangement still imposes its order on the large picture. From left to right, as the light becomes brighter, so the rhythm of the verticals becomes swifter, from the wide alternating pink and white expanses of the pillars in the shadow on the left to the forest of tapering candles on the right. The architecture, the furnishings, the light force the eye to look in that direction. While the prince-brothers, laden with gold embroideries but in the shadow, jam the composition on the left, the ripple of the busts and heads of the chamberlains, looking toward the right, in a soft light, sets off the pale bouquet of the princesses. The painter did not vary the colours of the dresses[12] or contrast the women's poses, having one leaning or another swaying: a three-quarter pose for Caroline and Pauline, full-front for Elisa, Hortense and Julie, they stand as straight as columns, a hieratic stance barely enlivened by the way they hold their heads and arms. In this unlit area, the aim was to "mass" the white silhouettes in an effort to balance the brighter ones of the pope and the cardinals. At the same time, the princesses, having refused to seem to be serving Josephine, are ostensibly doing nothing. They had declined to "bear" the empress's train, consenting only to "hold" it: a subtle distinction David was careful not to express in paint, leaving that role to the lady-in-waiting and the tirewoman. Pauline, when she visited David's studio with the painter Gérard, supposedly approved the idea of the change the latter suggested,[13] but we have no record of what she thought of her own image. It is in vain that we might think we read a feeling of hostility toward Josephine on the princesses' countenances: David gave them, as he did to most of the onlookers, an expression of attentive serenity that is disturbed by nothing.

Everything is vertical in this left third, over which looms the figure of the grand *maréchal* of the palace, Duroc [19], and where we can make out the one identified figure of a child in the painting: little Napoleon-Charles [28]. Placed behind the prayer stool, wearing a red velvet costume with a collarette, he finally gave up trying to get away from his mother, as the drawings showed him, and is looking gravely at his uncle who is about to crown his grandmother. If David thus makes him stand out (he is almost a pendant of the pope), placing him against a white pillar and lighting him well, it is because for the time being this son of Louis is the heir apparent of the Bonaparte dynasty six or seven months after its founding. We know that, born in Paris on 11 October 1802, he was to die at The Hague on 5 April 1807, before the painting was completed.

The first "pause" in the procession intervenes felicitously with the figure of Mgr de Belloy [32], who, owing to his ninety-five years, had the privilege of remaining seated. The elder, in half-length, his head covered by a red cowl, is set apart by the dark masses of his two grand vicars, Lejeas [31] and Astros [33], who flank him, and by the vacant prayer stools.

The space devoted to the coronation, the heart of the composition, plays with the sequence of red and white triangular shapes, from the languid pair of the lady-in-waiting and the tirewoman [34, 36] to the erect silhouette of Napoleon and through Josephine's prostrate position. Her face stands out against the shining, gorgeous cope of the crucifer [55] about whom David was so concerned. The cope, with its gold embroideries, is indeed a superb piece of painting. Its ochre-yellow tone enhanced by delicately hued flowers somehow plays the same role as the gold ground of the primitives with its punched motifs. David has diffused around Josephine's miraculously rejuvenated profile the luminous, ethereal and sacred space haloing the Madonnas of medieval times that this dawning nineteenth century is beginning to appreciate. Not since Theodora and the Byzantine apotheosis of Ravenna, had an empress received such a glorification from an artist.

How Many Figures?

Even David never really knew how many figures he had represented: "You have to see it to get an idea. It contains over 180 figures and of this number around 130 perfectly faithful portraits". This account from Hutin to Daru, 26 September 1907, is the closest to the truth.[14]

"In this large and beautiful composition there are, along with the hundred persons who stand out distinctly and who are in the boxes, ninety-one full-length figures at the front of the stage who all have their precise, fully characterised roles".[15] We have some difficulty in justifying these numbers: calling them all "full-length" figures is rather more questionable.

"You can distinguish over two hundred life-size figures".[16]

"Everyone rushed to be portrayed, and in a picture containing over two hundred figures, we can vouch that the main ones (a hundred and more) are the true likeness of the personalities depicted".[17]

"[…] A picture which contains 210 persons, of whom nearly eighty are represented from head to foot".[18]

As we can see, the number of figures increases over the years, but that of the so-called true-to-life portraits dwindles! So what is the truth? Only a systematic count can clarify our ideas; undertaken for the purposes of this book, the number totalled 191 figures represented or suggested in the picture, of which only 164 should be considered as having a totally or partially describable physiognomy; the 27 others consist of an eye [42] or two [83], just one nose [40], just one mouth [44], a mask [54] and 22 crowns of head often reduced to a brown or white arc of a circle…Of these 164 persons, we count 129 men, of which 59 are identified (13 military men, 8 ecclesiastics), 8 uncertain identifications and 62 anonymous (16 ecclesiastics); 33 women, of which 15 are identified and 18 remain anonymous, and two children of which only one can be identified [28].

Who Appears in the Sacre?

Can we claim, along with Jules David, that "Napoleon appears surrounded by all the illustrious personalities of his kingdom whose names, in history, will forever be linked to his"[19] and that "aside from the family of the Emperor, all the civil and military dignitaries were depicted in the picture"?[20] Most certainly not. The *Sacre* is not at all one of those pantheons the nineteenth century was to be so fond of, from the *Apotheosis of Homer* by Ingres (1827, Musée du Louvre) to the hemicycle of the École des Beaux-Arts by Delaroche (1836–41).

If we compare the lists of characters designated by the various sources, we realise that if the main actors—the imperial family, the great dignitaries, the *maréchaux*, the high clergy for the most part—are not a problem, this is not the case for a number of other figures who still lack an identity or, what is hardly better, are given more than one.

Without claiming to resolve all the issues, we felt we would make the task of identification, that can only go forward, easier by giving a number to each of the figures we can make out in the Louvre painting. We have even taken into account individuals who appear only as a nose, a mouth or more often the top of the head, aware that sometimes that is the last trace of a figure that a drawing indicated had been planned to be "complete". The example of Kellermann [3], of whom the painting only shows a small part of his face, his hat and Charlemagne's crown he is holding, urged us to this circumspection. Thus by "registering" them in the most neutral manner, starting from the left, and considering in sequence the "pit", then each of the six boxes, the census avoids the inconvenients of the "hierarchical" numbering systems that all begin with Napoleon, Josephine and the pope, who are numbered 1, 2, 3 and continue, some on the right with the dignitaries, others on the left with the brothers and sisters, in lists of which none can be easily compared with one another.

We shall give here the personalities the titles they bore at the time the painting was exhibited, that is, at the beginning of 1808.

How Can We Identify the Actors of the Sacre?

In his notebooks David left several lists of people he intended to represent in the picture. But he made several choices which we sometimes can understand (such as the exclusion of Denon, the director of the museum, who was opposed to David over the price of 100,000 francs he wanted for each painting). Of approximately seventy names written down, approximately twenty-five can be found in the painting.[21] The sound basis for an identification should be sought in the old descriptions and engravings accompanied that are accompanied by a numbered list.

The *Nouvelle description du tableau exposé au musée Napoléon, représentant le Sacre de LL. Majestés Impériales et royales, peint par M. David* (Paris, 1808) names forty-three of these actors, the most important, either by name, title or function which permits an identification, and six others are vaguely designated: "a bishop carrying a cross" [55], "a Greek bishop" [69], "a priest holding a gold crosier" [68], "several priests one of whom carries an antique vase" [99] and the "two choirboys" [97, 100]. In the upper boxes, only the painter Vien is named, because Napoleon recognised him [117].

Oddly, although more complete, it omits several names that figured nonetheless in the earlier *Description*, that mentioned only twenty-two persons: Cardinal Fesch [85] and the three honorary *maréchaux* Lefebvre [1], Kellermann [3] and Pérignon [8], who are further recognisable by Charlemagne's regalia they carry.

The engraving by Massard, deposited on 12 February 1808 at the Bibliothèque impériale, is numbered from 1 to 51; it repeats those forty-three names and allows us to add those of the grand *maréchal* of the palace Duroc [19], the prefect of the palace Rémusat [25], the senator comte d'Harville [45] and the general treasurer [48]. This brings the total to fifty-one identified persons.

We have to wait for the catalogue of paintings of the Louvre published in 1959,[22] that integrates Massard's data, to see several suggestions arise, cautiously accompanied by question marks. The names of the two grand vicars are given: Lejeas [31] and d'Astros [33]; the cardinals might be Antonelli [53], de Bayane [55], Caselli [50] and (mistakenly) Cambacérès [82];[23] the Greek bishop would be the abbé Raphaël de Monachis, Greek deacon [69]; the ambassador of the Porte is named: Mohamed Sayd-Halet Effendi [152]. Last, *maréchal* Soult [39] is firmly designated.[24]

Taking into account the uncertainties expressed, the number of identified persons is close to fifty-five.

The replica of the painting, begun in 1808 and completed in Brussels in 1822, presently at Versailles, and that is reproduced by Jazet's accurate aquatint of 1823, was exhibited in England in 1822 with a complementary guide (*Account*). Illustrated by a plain numbered line etching,[25] the text is in English and was certainly written by David, who contributed several details. Aside from an obvious confusion between three of the ambassadors,[26] this valuable list confirms the names given by Massard and adds a number of others, in particular in the formerly anonymous group of chamberlains. The problem is that, in this second picture, David suppressed one of them [7] and often replaced the heads by other ones (usually younger). Nonetheless, it does seem that the new names, despite the new faces, belong to the persons he represented in 1806–8, whether or not they attended the sacre of 1804.

Here are the new names given by the 1822 *Account* for the chamberlains, who all became counts *de l'Empire*: the comtes d'Arjuzon [2], de Songis [4], de Viry ("de Very") [5], de Nansouty [13] (said to be "colonel general of the Dragoons" whereas he is in mufti), de Forbin [14], d'Aubusson de La Feuillade [18], d'Esterno ("Deternaud") [21], de Beaumont [26], de Bondy [30]. The case of the comte de Brigode [25] is disturbing: this name belonged to the person numbered 7 in the first version, a person who disappears in the second; in the latter, Brigode is the name given to the figure numbered 25, who represented Rémusat in the first version. There are also the comte de Bausset, prefect of the palace [23], Lucchesini, ambassador of Prussia [154] and Cardinal Pacca [82]. In the box on the left, David gives the names of himself [110] and of his

near relatives: his wife [111] between his two daughters [108, 114], Antoine Mongez [112], the poet Lebrun [121] and the musician Grétry [123].

David, in this document, designates the crucifer [55] as being the ecclesiastic mounting a mule who preceded the pope everywhere, that is, Cardinal Speroni—without naming him. He himself told us he used as a model for this impressive figure his friend Degotti, the stage decorator. To arouse the public's interest in his painting, he could not resist mentioning this comic episode of 1804, even more piquant in an Anglican country.

At this point approximately seventy-five persons have been identified.

Last, there is a second line engraving reproducing the Brussels picture with a list of personalities numbered 1 to 58. We know two proofs of it, one in the file relating to the painting at the château de Versailles, the other at Malmaison and coming from the library of San Donato,[27] but lacking references as to its date and place of publication. Obviously this document, intended for the French-speaking public and which cannot date from before 1822, must not have been a separate document and was probably joined either to the painting (which was in Belgium in 1822 but not shown, then in France from at least 1833 to 1898) or to a print like Jazet's (1823). It faithfully follows Massard, occasionally correcting him, but often using his numbers. Its only contribution is the identification of Mme Mongez [115]—but her right-hand neighbour [116] cannot be, as the engraving claims, M. Mongez, correctly located by the *Account* [112].

There are some characters who credible sources claim are portrayed in the *Sacre* but without stating where. In a letter of 4 March 1807 David asks the sculptor Jean-Guillaume Moitte (1746–1810), a member of the Institut since 1795, to pose for his painting the next day. His miniature portrait by Dumont about 1800[28] apparently permits an identification of him in the figure wearing the uniform of the Institut and decorated [125?], a figure suppressed in the second version.

Boutard, the critic of the *Journal de l'Empire* of 24 January 1808,[29] quotes the names of the architects Fontaine and Percier [161, 158?], the sculptor Claude Dejoux (1731–1816), member of the Institut [probably 120],[30] the antiquarian Chrysostome Quatremère de Quincy (1755–1849), elected to the Institut in 1804 [maybe 124][31] and Corvisart, Napoleon's physician and whose features, known by his portrait by Gérard,[32] we recognise in the white-haired man [119] whom David replaced in the second version by his Belgian pupil Odevaere.

The systematic study of the drawings carried out by Pierre Rosenberg and Louis-Antoine Prat (2002) revealed at the bottom of the drawing depicting him[33] the name of comte Rogari for the priest bearing the papal tiara [75]. But the study also raised the issue of the model of the Spanish ambassador [149]. All the sources of the period repeat, consistent with the real situation of 1804, the name Admiral Gravina. But the drawing that matches him bears the annotation of the name of his successor in Paris as of 1805, Alvaro de La Serna... So in the first version David chose to represent the ambassador in office in 1804 with the features of his successor in 1805. The half-length portrait, turned three-quarters to the left, of his former pupil Jean Naigeon (Beaune, 1757–Paris, 1832), painter and curator of the Luxembourg, is annotated: "Mr Naigeon from the recollection of my painting of the Coronation".[34] Rosenberg and Prat recognised him in the middle right-hand box [166].

In the boxes we might expect to see such dear friends as Mme Moitte, an artist and the author of *Mémoires*—perhaps [122] or [125]?—or Alexandre Lenoir (1761/62–1839), of whom David left two striking portraits in the Louvre (1817), a painting[35] and a drawing:[36] he is perhaps in [116].

So we have identified more than eighty persons with certainty, that is, almost half of the 164 physiognomies.

The Groups

The Imperial Family
Madame Mère, Letizia Bonaparte [105]—who, having remained in Rome, did not attend the ceremony—is surrounded in her box by her ladies-in-waiting, Mme de Fontanges [103] and the

maréchale Soult [107], her grand equerry Beaumont [106] and her chamberlains, MM. de La Ville [102] and de Cossé-Brissac [104]. From her box she overlooks the imperial couple of Napoleon [61] crowning his wife Josephine [52]; on the far left the emperor's two brothers, Joseph [6] and Louis [12], behind, their sisters Caroline Murat [16], Pauline Borghèse [17] and Elisa Bacciochi [20] and sisters-in-law Hortense [22], daughter of Josephine and wife of Louis, and Julie [27], wife of Joseph, last, Napoleon-Charles [28], the heir apparent, his mother, Hortense, holding his hand.

Near the altar are grouped, some in rear view, the great dignitaries bearing the "Regalia of Napoleon": the second consul and archtreasurer Lebrun [77] holding the sceptre; archchancellor Cambacérès [79], the hand of justice; the *maréchal* Berthier [89], the imperial orb; and the grand chamberlain Talleyrand [95], the basket for the robe. In the middle ground on the same side we see the *maréchal* Bernadotte [88]; the grand master of the horse Caulaincourt [90] and the viceroy of Italy, Eugène de Beauharnais [93], son of Josephine and brother of Hortense, who was supposed to hold the imperial ring.

Ladies-in-Waiting

Aside from the princesses, only two women in the pit are identified: Mme de La Rochefoucauld [34], lady-in-waiting to Josephine, and Mme de La Valette [36], her tirewoman, holding her train.

The Maréchaux

Pride of the empire, created on 19 May 1804, at first there were eighteen of them: in the painting there are only nine. Furthermore, they are there less for their military importance than as bearers of the imperial or historical "ornaments": we saw on the right Bernadotte [88] and Berthier [89]; four are at centre: Bessières [37], colonel general of the guard; Moncey [38], carrying the basket destined to carry the empress's robe; Sérurier [41], "honorary *maréchal*" carrying the pillow destined to receive the empress's ring; Murat [43], carrying the pillow of the empress's crown; the three other "honorary *maréchaux*" are relegated to the left and carry the "Regalia of Charlemagne": these are Lefebvre [1], with the sword; Kellermann [3], the crown; Pérignon [8], the sceptre. With the exception perhaps of Soult, whose face we perhaps make out [39], the other *maréchaux*—Jourdan, Masséna, Augereau, Brune, Lannes, Mortier, Ney, Davout—are missing.

Junot [29] is not a *maréchal*, contrary to what is indicated in the *Nouvelle Description* of 1808, but a colonel general of the Hussards, and is leaning on his sabre. He is in uniform like Eugène de Beauharnais [93].

The Clergy

The French and the Italian clergy take turns. The first group features the cardinal-archbishop of Paris, Mgr de Belloy [32], the only one, along with the pope, to be seated, being almost a hundred years old, flanked by his two grand vicars, Lejeas [31] on the left, d'Astros [33] on the right; Cardinal Fesch [85], half brother of Madame Mère and therefore uncle of the Bonaparte tribe, is surrounded by Italian prelates, but the last on the right is French, the master of the choirboys [101].

Pope Pius VII [72], blessing the imperial couple, is flanked by the cardinal legate Caprara [71]—whose balding forehead David insisted on being allowed to paint without a wig—and more to the left by Cardinal Braschi [70], nephew of his predecessor, Pius VI. Comte Rogari [75] carries the tiara. Cardinal Pacca [82] is beside Fesch. The identification of the cardinals Antonelli [53] and Caselli [60] needs confirmation, as does that of the "Greek patriarch" [69] with Raphaël de Monachis. The other members of the Italian clergy are "ideal" heads in which we should not seek portraits, even if David may have used models: antique like the bust of Caesar for [66], modern like Degotti for the crucifer [55].

The Ambassadors

They are assembled in the lower box, visible to the left of the altar: there are those of Spain, Gravina [149], of the United States of America, Armstrong [150], of Italy, Marescalchi [151], of the Porte (Turkey), Mohamed Sayd-Halet Effendi [152], of Austria, Cobenzl [153] and of Prussia, Lucchesini [154]. Is his right-hand neighbour, also glimpsed between two candelabra, an ambassador as well [155]?

We can easily understand the absence of a British ambassador … but we have seen that, doubtless on orders from the emperor, David had summoned to the painting some absent diplomats (Cobenzl and Sayd-Halet).

The Chamberlains

They form a remarkably pervasive group. We should distinguish the ones belonging to the emperor's household, dressed in red: the comtes de Viry [5] and de Bondy [30], Duroc [19], grand *maréchal* of the palace, Bausset [23] and Rémusat [25], prefects of the palace. Those of the empress are dressed in black: Nansouty, first chamberlain [13], Aubusson de La Feuillade [18]; as are those of the princesses: Hortense, d'Arjuzon [2]; and Julie, d'Esterno [21], or the chamberlain Songis [4]. We cannot make out the colour of the garb of Forbin [14], Pauline's chamberlain, nor of Brigode [7], the emperor's chamberlain. Four chamberlains (?) remain anonymous: [9, 10, 11, 15]. In red as well are Beaumont [26], knight of honour of Josephine, and Ségur [35], grand master of ceremonies.

The senators are in black with silver embroidery: Jaucourt [24], knight of honour of Julie, d'Harville [45], first equerry of Josephine. In black as well is Estève [48], treasurer-general of the crown.

The Artists

This is the field where we still have the most to discover: aside from David, Vien and several others, little research has been carried out on the upper sections of the picture, which besides being dark and remote, has never been clearly reproduced until now.

David [110], who depicted himself drawing,[37] is surrounded by his wife [111] and his twin daughters, Pauline Jeannin [108] and Émilie Meunier [114]; his sons and his sons-in-law, military men, are missing; his old master Vien [117], senator, is in the first row; his indispensable collaborator Rouget [109] is behind David; his pupil Mme Mongez [115] is very close (she made the mannequins for the maquette), in front of her husband, director of the mint [112].

Among the men from the world of art, his friend Alexandre Lenoir [116?], founder of the Musée des Monuments français, is there—but not Vivant Denon, director of the Musée Napoléon and adversary of both[38]—as well as Jean Naigeon [166], curator of the Luxembourg, and Quatremère de Quincy [124?], the theoretician of Neoclassicism whom David had known in Rome. Two sculptors, Moitte [118?] and Dejoux [120], represent the Fine Arts class of the Institut, but there is not a single painter from that institution: the two most outstanding, Vincent and Regnault, as well as the perpetual secretary, Joachim Lebreton, are hostile to David, whose role they constantly minimise. There had to be a poet: it would be Lebrun, known as Lebrun-Pindare [121], and a musician: at the time Grétry [123] was the most famous. Fontaine and Percier, the architects of the props for the ceremony, may be housed in the middle right-hand box [161, 158], but there is no mention of the presence of Isabey, the other artist of the day, who designed the costumes: perhaps because he was too close a friend of Gérard (who is not there, nor is Gros).

We shall have to put a name on these faces of friends, pupils for the most part, thronging the boxes, including several women [122, 129: in profile with a large black hat, 132, 142, 148, 156, 157, 159, 160, 162, 165, 168, 173, 174, 184, 185: blonde "with her hair down" and bodice open, 189]. The *Sacre* has not yet yielded all its secrets and may still have some surprises in store for us.

Notes

1. David was the first to equivocate. After 1804 he constantly refers to the painting by the words "the *Coronation*" and will retain the word in the *livret* of the Salon of 1808. In the meanwhile, however, in February 1808, two successive editions of a description of the painting appear, in which it is described as representing "the coronation of Their Majesties", according to the first, and "the *sacre* of Their Majesties", according to the second.

2. *The Marriage at Cana*: 6.77 x 9.94; *Le Sacre*: 6.21 x 9.79.

3. Neither *f*^{bat.} nor *1805–1807*.

4. This image is hidden by the more recent subject that repeats the two figures as they are painted in the large canvas. It was discovered by Mark Tucker, Vice Chairman of Conservation and Senior Conservator of Paintings at the Philadelphia Museum of Art, who published it with John Zarobell, Assistant Curator of European Painting and Sculpture before 1900, in the catalogue of the exhibition *Le Sacre de Napoléon peint par David*, edited by S. Laveissière.

5. C.-P. Landon, *Annales du Musée: Salon de 1808* (Paris, 1808), p. 9.

6. "Although [she was] absent, her son wished to have her represented in the picture, attended by her household". [Jacques-Louis David], *Account of the Celebrated Picture of the Coronation of Napoleon by M. David, First Painter to the Emperor* (London, 1822), p. 21, no. 57.

7. Emphasis added.

8. Louis Hautecœur, *Louis David* (Paris, 1954), p. 206.

9. There were curtains in the nave only; David invented them in the choir.

10. David, *Account* (1822), p. 5.

11. Antoine Schnapper, *Jacques-Louis David* (Paris, 1989), pp. 415–16, 418.

12. He was to change his mind in the second version of the painting, executed in Brussels in 1822, and now at Versailles, in which Pauline wears a pink dress. On the day of the coronation, Hortense wore a pink dress.

13. Jacques-Louis-Jules David, *Le peintre Louis David, 1748–1825. Souvenirs et documents inédits* (Paris, 1880), p. 431.

14. Schnapper, 1989, p. 609.

15. *Journal de Paris*, no. 343 (9 December 1807), p. 2453.

16. *Nouvelle description du tableau*, 1808, p. 3; Schnapper, 1989, p. 416.

17. David, *Autobiographie*, quoted here after David, 1880, p. 432; in Schnapper, 1989, p. 405.

18. David, *Account*, 1822, p. 4.

19. David, 1880, p. 434.

20. David, 1880, p. 425.

21. See Pierre Rosenberg and Louis-Antoine Prat, *Jacques-Louis David, 1748–1825. Catalogue raisonné des dessins* (Milan, 2002), 2: nos. 1594, 1639v, 1641, 1651v, 1653v, 1663v, 1670, 1732.

22. Charles Sterling and Hélène Adhémar, *La Peinture au musée du Louvre. École française XIX^e siècle* (Paris, 1959), 2: no. 557, with numbered sketch, in which Lefebvre and Kellermann are inverted, as are Laville and Cossé-Brissac.

23. These identifications must have been made after the *Procès-Verbal* by Ségur, 1805, that gives the respective positions of the officiants. But, as we know, David did not always conform to the actual ceremony.

24. The rare portraits of Soult do not contradict this identification; we do not know if it has another source. David, Lebrun and Grétry, equally cited in this catalogue, appear to be its only borrowing from the 1822 list mentioned below.

25. Schnapper, 1989, reproduces this etching p. 414, fig. 110, and its identifications in an updated form.

26. Armstrong is said to be Marescalchi; Marescalchi, Cobenzl; Cobenzl, Armstrong.

27. Reproduced in Thierry Lentz, *Le Sacre de Napoléon. 2 décembre 1804* (Paris, 2003), pp. 130–31 (as being Massard's, 1808; the captions were altered) and in *Napoléon. Le Sacre*, exh. cat. (Ajaccio, 2004), no. 74 (entry by Bernard Chevallier).

28. Wood; diam. 0.08 m. Private coll.; repr. Gisela Gramaccini, *Jean-Guillaume Moitte (1746–1810). Leben und Werke* (Berlin, 1993), I, frontispiece.

29. Schnapper, 1989, p. 415.

30. His half-length self-portrait (bronze, H. 0.475) dated 1812, given by him to his native town and preserved at the Sarret de Grozan Museum in Arbois (Jura), permits the identification.

31. David jotted down "dejoux" and "quatremère" in the list of notebook 8, f. 34; Rosenberg and Prat, 2002, no. 1670.

32. Musée national des châteaux de Versailles et de Trianon, M.V. 5071.

33. Rosenberg and Prat, 2002, no. 1659; see also nos. 1573v and 1574.

34. Besançon, Musée des Beaux-Arts, D. 1973; Schnapper, 1989, p. 538, fig. 1253; Rosenberg and Prat, 2002, nos. 1673 and 1727v.

35. Schnapper, 1989, no. 228.

36. Rosenberg and Prat, 2002, no. 222.

37. There are two self-portraits by David in his notebooks for his figure in the painting (Rosenberg and Prat, 2002, nos. 1673 and 1727v). The second is weaker than the first. Agnès Mongan (*David to Corot. French Drawings in the Fogg Art Museum*, Cambridge, Mass., 1996, p. 109) used this as an argument to withdraw it from David and suggest attributing it to Jean-Baptiste Isabey, which is paradoxical, owing to that artist's extreme virtuosity… Since then this assumption has led to the consideration that the selfsame Isabey (a productive miniaturist but rarely an easel painter) had painted David's portrait in the *Sacre* and conclude that thereby David was present in his work and at the same time had excluded himself from it by having himself painted by someone else…(Warren Roberts, *Jacques-Louis David, Revolutionary Artist: Art, Politics, and the French Revolution* [Chapel Hill: University of North Carolina Press, 1989], p. 161). We are told this would moreover reflect the (real) inner conflict between the former Jacobin and Napoleon's appointed painter.

38. His name appears, however, in notebook 8, f. 34, "Denon" list (Rosenberg and Prat, 2002, no. 1670).

PEOPLE REPRESENTED IN
LE SACRE (THE CORONATION)

The diagram reproduced on the inside back cover enables the reader to locate the figures represented in the painting. A total of 191 figures have been identified. They are numbered starting from the viewer's left, in order of appearance, regardless of the plane they occupy. First are those people in the choir of Notre-Dame, in the "pit" or "orchestra stalls" (A), then those who occupy each of the six galleries or "boxes" (B–G).

The figures who appear only in painting I (the version in the Louvre, 1805–8) have been so specified, as [7] and [118], for example, and, if need be, the figures who replace others in painting II (the version in Versailles; painted in Paris in 1808 and in Brussels in 1822) have been so identified. Asterisks serve as cross-references to people in this list.

A. THE PIT [1–101]

[1] **Lefebvre**, François-Joseph (1755–1820); general; senator (1800); honorary *maréchal* (1804); duc de Dantzig (1807). In the painting, he is carrying Charlemagne's sword (not Kellermann: see 3).

[2] **Arjuzon**, Gabriel-Thomas-Marie d' (1761–1851); chamberlain of Hortense*; count *de l'Empire* (1809).

[3] **Kellermann**, François-Étienne-Christophe (1735–1820); senator (1799); lieutenant general (1800); honorary *maréchal* (1804); duc de Valmy (1808). In the painting, he is carrying Charlemagne's crown (neither Lefebvre: see 1; nor Pérignon: see 8).

[4] **"Songis"**: the "comte de Songis, chamberlain," according to David (*Account*, 1822, no. 44). The only Songis with a count's title is General Nicolas-Marie de Songis des Courbons (1761–1810), first artillery inspector general of the Grande Armée (1805–9), who attended the coronation. His portrait by Paulin Guérin after Robert Lefèvre (Musée de l'Armée), however, does not in the least resemble figure 4.

[5] **Viry**, François-Marie-Joseph-Justin de (1737–1813); ambassador of Savoy in the United Provinces of the Netherlands, London, Madrid, then Paris (1764–77); mayor of Viry; prefect of the Lys (2 March 1800); senator (3 February 1804); chamberlain of the emperor* and knight of honour of the pope* for the coronation; count *de l'Empire* (26 April 1808).

[6] **Joseph Bonaparte** (1768–1844); elder brother of Napoleon*; marries (1791) Julie* Clary; senator (1802); French prince (1804); grand elector (1804); lieutenant general (1806); king of Naples and of Sicily (30 March 1806–1808); king of Spain and the Indies (4 June 1808–1813); in exile in Brussels with the comte de Survilliers after the emperor.

[7] **Brigode**, Louis-Marie-Joseph de (1776–1827); chamberlain; attached to the service of the pope* for the coronation; knight *de l'Empire* (January 1809), then count *de l'Empire* (August 1809) (this figure only appears in painting I).

[8] **Pérignon**, Catherine-Dominique (1754–1818); lieutenant general (1793); senator (1801); honorary *maréchal* (1804); governor of Parma; 1806; count *de l'Empire*; governor of Naples until 1811; marquis de Pérignon. In the painting, he is carrying Charlemagne's sceptre (not Kellermann: see 3).

[9–11] Unidentified chamberlains.

[12] **Louis Bonaparte** (1778–1846); brother of Napoleon*; marries (3 January 1802) Hortense* de Beauharnais; brigadier general (1803), then lieutenant general (1804); French prince and senator by rights (1804); grand *connétable de l'Empire* (1804); king of Holland (5 June 1806–1810); *pair* de France (2 June 1815); known after 1814 as comte de Saint-Leu.

[13] **Nansouty**, Étienne-Marie-Antoine Champion de Nansouty (1768–1815); general (1799); colonel general of the Dragoons; first chamberlain of the empress* (1804); count.

[14] **Forbin**, Auguste de (1777–1841); chamberlain of Pauline* (1803); baron *de l'Empire* (1809); count (Restoration); director general of museums (1816). Forbin was a painter as well, a former pupil of David*.

[15] Unidentified chamberlain.

[16] **Caroline** (Marie-Annonciade, known as) **Murat**, née **Bonaparte** (1782–1839); sister of Napoleon*; marries (1800) Murat*; princess; grande duchesse de Berg (15 March 1806); queen of Naples (15 July 1808).

[17] **Pauline** (Marie-Paulette, known as) **Borghèse**, née **Bonaparte** (1780–1825); sister of Napoleon*; marries (1797) General Leclerc, then (31 August 1803) Prince Camille Borghèse; Princess Borghèse (1803); duchesse de Guastalla (30 March 1806).

[18] **Aubusson de La Feuillade**, Pierre-Hector-Raymond d' (1765–1848); count; chamberlain of the empress*. Plenipotentiary minister to the queen of Etruria (1806); then (17 December 1807) ambassador to the king of Naples, Joseph* then Murat*.

[19] **Duroc**, Géraud-Christophe-Michel (1772–1813); general (1801); governor of the Tuileries (20 November 1801); grand officer of the emperor's palace (1804); *maréchal*; grand *maréchal* of the palace (1804); duc de Frioul (1807); senator (1813).

[20] **Elisa** (Maria-Anna, known as) **Bacciochi**, née **Bonaparte** (1777–1820); sister of Napoleon*; marries (1 May 1797) Félix-Pascal Bacciochi (1762–1841); princess of Lucca-Piombino (March 1805); grande duchesse de Toscane (1809).

[21] **Esterno**, Ange-Philippe-Honoré d' (1770–1827); chamberlain of Elisa*, count-baron *de l'Empire*. David (*Account*, 1822, no. 49) calls him "the Count Deternaud, knight of honour to the queen of Spain [Julie*]".

[22] **Hortense** (-Eugénie) **Bonaparte**, née **de Beauharnais** (1783–1837); daughter of Joséphine*, sister of Eugène*; marries (1802) Louis* Bonaparte; princess; queen of Holland (5 June 1806–1810); comtesse de Saint-Leu; mother of Napoleon-Charles* (1804–1831) – born 18 December 1804, two weeks after the coronation – and of Louis-Napoleon (1808–1873), who will become the emperor Napoleon III.

[23] Bausset, Louis-François-Joseph de (1766/70–1835); prefect of the palace of the Tuileries and chamberlain of Napoleon* (1804?); baron de Bausset-Roquefort (1810); count.

[24] Jaucourt, Arnail-François de (1757–1852); senator (1803); chamberlain, knight of honour of Julie* Clary; intendant of the household of King Joseph; count de l'Empire (1808); marquis (1817).

[25] Rémusat, Augustin-Laurent de (1762–1823); chamberlain, prefect of the palace; count (replaced by Brigode*, chamberlain in painting II).

[26] Beaumont, André Bonnin de La Bonninière de Beaumont (1761–1838); chamberlain and master of ceremonies for the empress* (1804–9); baron de l'Empire (1811); knight of honour of the Empress Joséphine* (1812–14).

[27] Julie (Marie-Julie, known as) Bonaparte, née Clary (1771–1845); princess; marries (1 August 1794) Joseph* Bonaparte; queen of Naples and of Sicily (1806–8); queen of Spain and of the Indies (1808–13); exiled in Brussels after the empire with the title comtesse de Survilliers.

[28] Napoleon-Charles Bonaparte (11 October 1802–5 April 1807); son of Louis* and Hortense*.

[29] Junot, Jean-Andoche (1771–1813); general (1798); governor of Paris (1800–1803); colonel general of the Hussars (1804); ambassador to Portugal (April–October 1805); governor of Paris (1806–7); duke d'Abrantès (1807); governor of Portugal (1807–8).

[30] Bondy, Pierre-Marie Taillepied de Bondy (1766–1847); chamberlain of Napoleon* (1804); count; prefect of the Rhône (7 August 1810–1814), then of the Seine (1815), by virtue of which he was one of the three negotiators of the capitulation of Paris.

[31] Lejeas, François-Antoine (1744–1827); vicar general of Paris; future bishop of Liège.

[32] Belloy, Jean-Baptiste de (1709–1808); bishop of Marseille (1755–1801); cardinal archbishop of Paris (9 April 1802); senator (1802); count de l'Empire (1808). He is the doyen of the painting.

[33] Astros, Paul-Thérèse-David d' (1772–1851); nephew of Portalis; vicar general of Paris (1807).

[34] La Rochefoucauld, Adelaïde-marie-Françoise de (1772–1814), née Pyvart de Chastulé; cousin of Alexandre de Beauharnais; countess; lady-in-waiting to the empress* (1804–10 February 1810).

[35] Ségur, Louis-Philippe de (1753–1830); colonel of the Dragoons (1783); ambassador to Russia (1784–89); member of the Legislative House (1801); senior councillor of state (1802); member of the Académie française (1803); grand master of ceremonies of the palace of the emperor (9 July 1804), he writes the Procès-verbal de la cérémonie du Sacre . . . , 1805; count de l'Empire (23 May 1808); senator (5 April 1813).

[36] La Valette, Lavalette, Émilie de, née de Beauharnais, cousin of Joséphine*; marries Antoine-Marie Chamans, comte de Lavallette (1769–after 1822), aide-de-camp of Bonaparte*, then postmaster general; tirewoman of the empress*; in 1815, at the Conciergerie, she took the place of her husband, sentenced to death, to allow him to escape.

[37] Bessières, Jean-Baptiste (1768–1813); brigadier general (1800), then lieutenant general (1802); maréchal (1804); colonel general of the Imperial Guard (1805); duc d'Istrie (1809).

[38] Moncey, Bon-Adrien Jannot de (1754–1842); lieutenant general (1794); inspector general of the gendarmerie (1801); maréchal (19 May 1804); duc de Conegliano (25 July 1808); as major general of the National Guard (8 January 1814), he organises the defence of Paris. In the painting, he is carrying the basket intended to receive the mantle of the empress*.

[39] (?) Soult, Jean de Dieu (1769–1851); brigadier general (1794), then lieutenant general (1799); maréchal de l'Empire and colonel general of the Guard (19 May 1804); duc de Dalmatie (1808). All that can be seen of this figure is the face, which is rather similar to the portraits of Soult; only the 1959 Louvre catalogue, no. 23 bis, gives this identification.

[40] nose.

[41] Sérurier, Jean-Mathieu-Philibert (1742–1819); brigadier general (1793); senator (1799); honorary maréchal (1804); governor of the Invalides; count. In the painting, he is carrying the pillow intended to receive the ring of the empress*.

[42] eye.

[43] Murat, Joachim (1767–1815); first aide-de-camp of Bonaparte (1796); brigadier general (1796), then lieutenant general (1799); marries (1800) Caroline* Bonaparte; governor of Paris (15 January 1804); maréchal (19 May 1804); grand admiral and prince (1805); grand duc de Berg (15 March 1806); king of Naples (15 July 1808). In the painting, he is carrying the pillow intended to receive the crown of the empress*.

[44] mouth.

[45] Harville, Louis-Auguste Juvénal des Ursins, comte d'Harville (1749–1815); inspector general (1798); senator (1801); lieutenant general (1803); first equerry, then (12 June 1806) knight of honour of the empress*; count de l'Empire (May 1808); governor of the Tuileries and the Louvre.

[46–47] crowns of heads.

[48] Esteve, Xavier (1772–1853); chief treasurer of the government (1801), then of the crown (1804); count de l'Empire.

[49] crown of head and eyebrow.

[50] unknown.

[51] crown of head.

[52] Joséphine (Marie-Joseph-Rose, known as) Bonaparte, née de Tascher de La Pagerie (1763–1814), marries (1779) the vicomte Alexandre de Beauharnais (1760–1794), then (9 March 1796) Napoleon* Bonaparte; empress of the French (1804); mother of Eugène* and Hortense*.

[53] (?) Antonelli, Leonardo, cardinal, attendant bishop on the occasion of the coronation; bishop of Porto; Grand Penitentiary.

[54] face.

[55] Crucifer: ought to be the abbé Salamon; the figure in the painting was actually posed by the painter Ignace-Eugène-Marie Degotti (1759?–1824). A figure sometimes identified as "the cardinal of Bayane?" (Alphonse-Hubert de Lattier de Bayane, 1739–1818) or, by implication, the nuncio Speroni.

[56] Bareheaded priest; full front; eyes raised.

[57–58] crowns of heads.

[59] Bareheaded priest; full front.

[60] Book bearer: A figure sometimes identified as "the cardinal Caselli?" (Carlo Francesco Caselli, 1740–1828, deacon of the Gospel on the occasion of the coronation).

[61] Napoleon I; Napoleon Bonaparte (Ajaccio, 15 August 1769–Longwood, 5 May 1821); brigadier general (1793), then lieutenant general (1795); general in chief of the Army of the Interior (26 October 1795); marries (9 March 1796) Joséphine* de Beauharnais; member of the Institut (22 December 1797); first consul (10 November 1799); emperor of the French (18 May 1804; crowned 2 December); king of Italy (17 March 1805; crowned in Milan 26 May).

[62–65] crowns of heads.

[66] Bareheaded Italian priest, full front; the head is painted after a bust of Julius Caesar.

[67] crown of head.

[68] Roman prelate bearing the pope's* crosier.

[69] Patriarch of the Greek Church (the abbé Raphaël de Monachis, Greek deacon?).

[70] Braschi-Honesti, Romuald; cardinal; nephew of Pope Pius VI, predecessor of Pius VII*; deacon attendant to the throne on the occasion of the coronation.

[71] Caprara, Jean-Baptiste (1733–1810); cardinal, legate of the pope* in France; negotiator for the pope in preparations for the coronation; indisposed, he does not attend; conducts the service for the coronation of Napoleon,* king of Italy, at Milan (26 May 1805).

[72] Pius VII, Gregorio Luigi Barnaba Chiaramonti (1742–1823), elected pope (14 March 1800).

[73] Mitred bishop (the lower part of the face is hidden).

[74] Roman priest.

[75] **Rogari**, count. Is carrying the papal tiara.

[76] crown of head.

[77] **Lebrun**, Charles-François (1759–1824); third consul (1799–1804); prince archtreasurer *de l'Empire*, senator by rights and senior councillor of state (18 May 1804); governor general of the *départements* of Genoa, Montenotte and the Apennines after the annexation of the Ligurian Republic (1805); duc de Plaisance (1806); lieutenant general of the emperor (1810), then governor general (1811–13) of annexed Holland. In the painting, he is carrying the sceptre of the emperor*.

[78] Priest.

[79] **Cambacérès**, Jean-Jacques-Régis (1753–1824); elected to the Convention (1792); president of the Conseil des Cinq-Cents (1796); member of the Institut (1797); advocate; minister of justice (1799); second consul (1799–1804); archchancellor *de l'Empire*, senator by rights and senior councillor of state, with the title of prince (1804); duc de Parme (March 1808). In the painting, he is carrying the hand of justice of the emperor*.

[80] crown of head.

[81] Ecclesiastic, wearing a hood.

[82] **Pacca**, Bartolomeo (1756–1844); cardinal; papal nuncio at Cologne (1786–94), then at Lisbon (1795–1802); pro-secretary of state (18 June 1808) (figure 82 has been mistakenly identified as the "cardinal Cambacérès?" [Étienne-Hubert Cambacérès, 1756–1818, brother of the archchancellor*]).

[83] Ecclesiastic (eye).

[84] Ecclesiastic (we call him "the inquisitive one").

[85] **Fesch**, Joseph (1763–1839, half brother of Madame Mère* and uncle of Napoleon* ; archdeacon of Ajaccio (1787); archbishop of Lyon (25 July 1802); cardinal (27 March 1803); ambassador of the republic to the Holy See (4 April 1803); grand almoner of the emperor (1804); senator (1 February 1805); coadjutor to the bishop of Ratisbon, remains archbishop of Lyon (28 May 1806). Fesch was also a great collector of paintings.

[86] crown of head.

[87] Ecclesiastic.

[88] **Bernadotte**, Jean-Baptiste-Jules (1763–1844); *maréchal* (1804); prince de Ponte Corvo (1806); royal prince of Sweden (1810) and of Norway (1814), made king on 5 February 1818; during the coronation, he carries the chain of Napoleon*.

[89] **Berthier**, Louis-Alexandre (1753–1815); brigadier general (1795); minister of war (1799–August 1807); *maréchal* (19 May 1804); master of the hunt and senator by rights (July 1804); army chief of staff (August 1805); prince de Neuchâtel (March 1806); vice *connétable* (August 1807); prince de Wagram (August 1809). In the painting, he is carrying on a pillow the cruciferous orb of the emperor.

[90] **Caulaincourt**, Armand-Augustin de (1773–1827); grand master of the horse (June 1804); lieutenant-general (February 1805); senator (1805); count; duc de Vicence.

[91] Unknown.

[92] Priest with calotte.

[93] **Eugène de Beauharnais** (1781–1824); son of Joséphine*; brother of Hortense*; colonel general of the Hussars (1804); senator by rights (1804); viceroy of Italy (1805); made duc de Leuchtenberg by the king of Bavaria (1817). During the coronation, he was carrying the ring of Napoleon*.

[94] Unknown.

[95] **Talleyrand-Périgord**, Charles-Maurice de (1754–1838); minister of foreign affairs (15 July 1797–20 July 1799; 22 November 1799–10 August 1807); grand chamberlain and senator by rights (11 July 1804–28 January 1809); prince de Bénévent (5 June 1806); vice grand elector (17 August 1807). In the painting, he is carrying the basket intended to receive the mantle of the emperor.

[96] Ecclesiastic.

[97] Choirboy.

[98] Bareheaded ecclesiastic; eyes cast down.

[99] Bareheaded ecclesiastic; bearing a ewer on a tray.

[100] Choirboy bearing a censor.

[101] The master of the choirboys.

B. BOX OF MADAME MÈRE [102–7]

[102] **La Ville, (Laville), de Villastellone**, Victor-Hercule-Joseph-Ferdinand de (1753–1826); chamberlain of the king of Sardinia; member of the *consulta* of the provisional government of the Italian republic (July 1800); prefect of the department of the Po River (1800–1805); chamberlain of Madame Mère (4 May 1805); knight *de l'Empire* (3 June 1808); senator (14 December 1809); count *de l'Empire* (9 March 1810) (not Cossé-Brissac: see 104).

[103] **Fontanges**, Caroline de, baroness, then countess; lady-in-waiting to Madame Mère*.

[104] **Cossé-Brissac**, Hyacinthe-Hugues-Timoléon, duc de Cossé, comte de Brissac (1746–1813); lieutenant general (1791); grand chamberlain of Madame Mère*; senator (18 August 1807); count *de l'Empire* (28 April 1808) (not La Ville: see 102).

[105] **Letizia Bonaparte**, née Ramolino (1749–1836), **Madame Mère**; half sister of Fesch*; mother of Napoleon*, Joseph*, Louis*, Jérôme, Lucien, Pauline*, Caroline*, and Elisa*.

[106] **Beaumont**, Marc-Antoine de La Bonninière de Beaumont (1763–1830); marries (1801) Julie Davout, sister of the future *maréchal*; lieutenant general; grand equerry and first chamberlain to Madame Mère*; senator (14 August 1807); count *de l'Empire* (26 April 1808).

[107] **Soult**, the *maréchale*, née Louise berg (1771–1852), lady-in-waiting to Madame Mère*.

C. BOX OF DAVID [108–25]

[108] **Jeanin**, Pauline, née David (1786–1870), daughter of David*; marries (24 May 1806) Jean-Baptiste Jeanin (1769–1830), lieutenant general, then general, baron; separated (1824).

[109] **Rouget**, Georges (1783–1869), painter; assistant of David* in particular for the execution of the two versions of the *Coronation*.

[110] **David**, Jacques-Louis (1748–1825); first painter of the emperor* (1804); father of Pauline Jeanin* and Émilie Meunier*, twins.

[111] **David**, Marguerite-Charlotte, née Pécoul (1764–1826), marries (1782) Jacques-Louis David*; separated (1790); divorced (16 March 1794); remarries (12 November 1796).

[112] **Mongez**, Antoine (1747–1835); commissary of the republic for the administration of the mint (1792, on David's recommendation); member of the Institut (1796); director of the Paris mint (1804–27). David painted him with his wife [115] in a double portrait dated 1812 (Louvre, M.I. 145; Schnapper, 1989, no. 208).

[113] Unknown.

[114] **Meunier**, Émilie, née David (1786–1863), daughter of David*; marries (27 March 1805) Claude-Marie Meunier (1770–1846), colonel, baron (1808), then general (1810).

[115] **Mongez**, Angélique, née Le Vol (1775–1855); wife of Antoine Mongez [112]; painter, pupil of David; she dressed the dolls David used to study the composition of the groups in the painting.

[116] (?) **Lenoir**, Alexandre (1761–1839), curator of the Musée des Monuments français.

[117] (?) **Vien**, Joseph-Marie (1716–1809); painter; prix de Rome (1743); member of the Académie royale de peinture (1754); first painter of the king (1789); member of the Institut (1795); senator (25 December 1799); count *de l'Empire* (26 April 1808); master of David*. He is second oldest after Belloy (32).

[118] (?) **Moitte**, Jean-Guillaume (1746–1810), sculptor; prix de Rome (1768); member of the Académie royale (1783) and

of the Institut (1795); president of the administrators of the Louvre. (Figure 118 appears only in painting I.)

[119] (?) Corvisart, Jean-Nicolas (1755–1821), physician of the first consul (July 1801); first physician to the emperor* (1804); baron *de l'Empire*; member of the Institut (replaced by Odevaere, painter, pupil of David* in painting II).

[120] (?) Dejoux, Claude (1731–1816), sculptor; academician (1779); member of the Institut (1795).

[121] Le Brun-Pindare, Ponce-Denis Ecouchard-Lebrun, known as (1729–1807), writer, poet.

[122] Unknown woman.

[123] Grétry, André (1741–1813), musician, composer, member of the Institut.

[124] (?) Quatremère de Quincy, Antoine-Chrysostome (1755–1849); antiquarian and theoretician; secretary of the Conseil général de la Seine (1800); member of the Institut (1804); perpetual secretary to the Académie des Beaux-Arts (1816–39).

[125] Unknown woman.

D. Box [126–48]

Pupils and friends of David. No figure identified.

E. Box of the Ambassadors [149–55]

[149] Gravina, Charles de (1756–1806), duke; admiral; as representative of the Spanish government (1804–5), he attends the coronation as ambassador of the queen of Etruria. In the painting, he is depicted with the features of his successor, Alvaro de La Serna (1773–1841).

[150] Armstrong, John, Jr (1758–1843), general; senator of Pennsylvania (1800); ambassador of the United States to France (1804–10).

[151] Marescalchi, Ferdinando de (1764–1816); minister of foreign affairs of the kingdom of Lombardy; ambassador of Italy; count.

[152] Mehemet Seyd-Halet Effendi, ambassador of the Porte (Ottoman empire, Turkey) in Paris, from 22 September 1803 until September 1809. David depicted him with the features of his predecessor, Morali Seyyid Ali Efendi, ambassador in Paris from the end of 1796 to 16 July 1802, after an engraving by L.-J. Cathelin (1799; Salon of 1800), reproducing a pastel by Joseph Boze (lost from the 1840s).

[153] Cobenzl, Jean-Philippe de (1741–1810), count; cousin of Louis (chancellor of Austria 1801–5); ambassador of Austria in Paris (1801–5); Metternich succeeds him.

[154] Lucchesini, Jérôme de (1752–1823); marquis; librarian of Frederick II; ambassador of Prussia to France under the consulate and at the beginning of the empire; resigns after Iéna (1806); chamberlain of Elisa at Lucca.

[155] Ambassador?

F. Box [156–69]

[158] (?) Percier, Charles (1764–1838), architect.

[161] (?) Fontain, Pierre-Léonard (1762–1853), architect.

[166] Naigeon, Jean (1757–1832), painter, pupil of David; member of the Commission des arts et des sciences (1793–1800); curator of works of art confiscated to the Revolution, housed in the hôtel de Nesles (1794); curator of the Luxembourg Palace museum (18 January 1802–1829).

G. Box [170–91]

No figure identified.

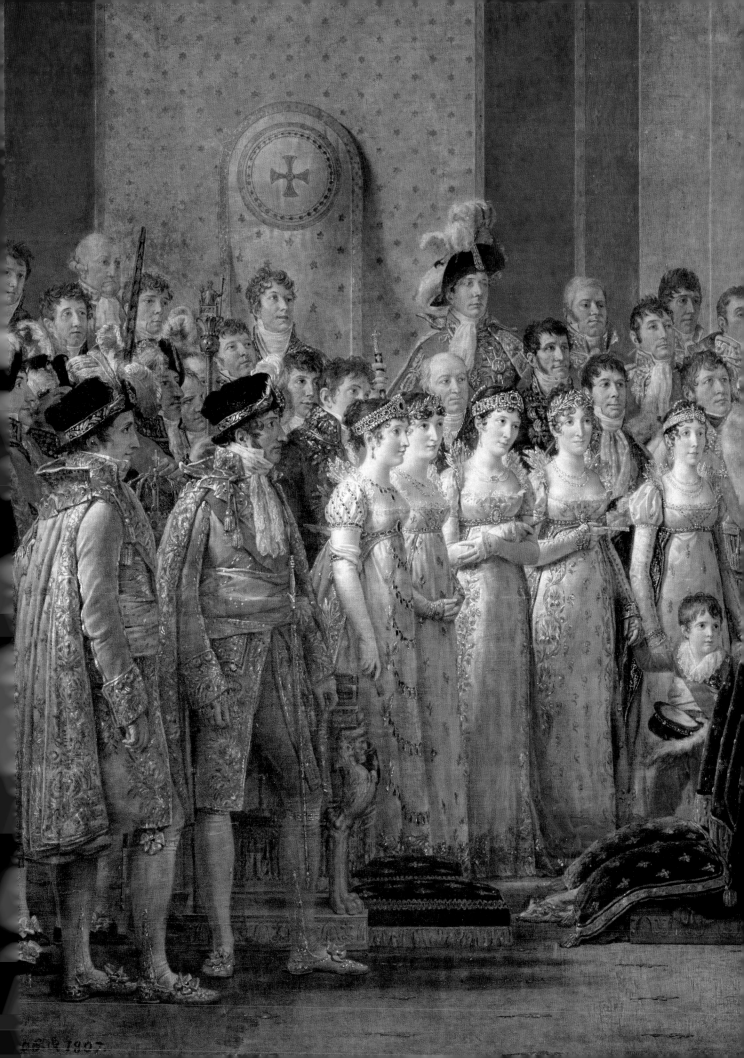

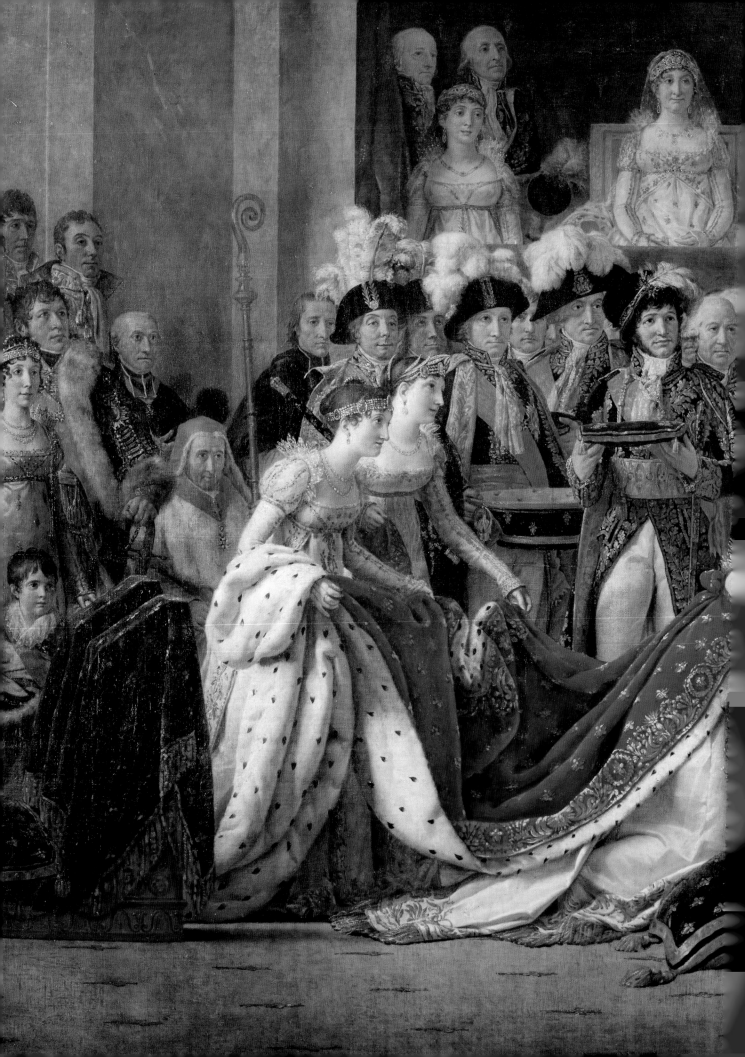

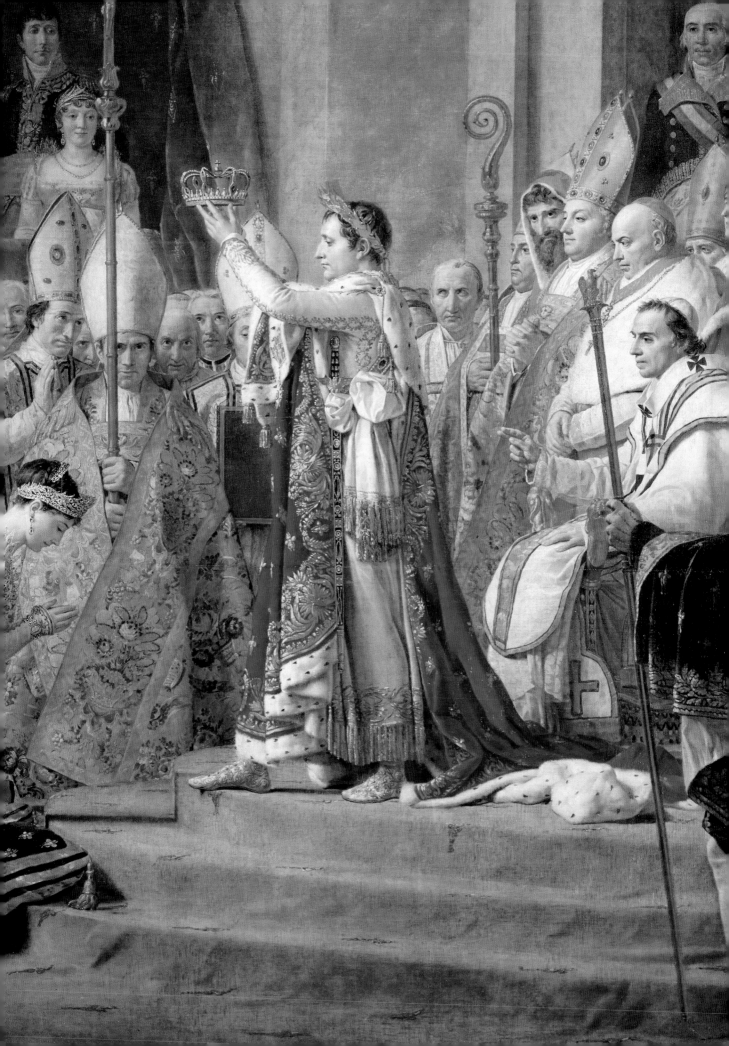

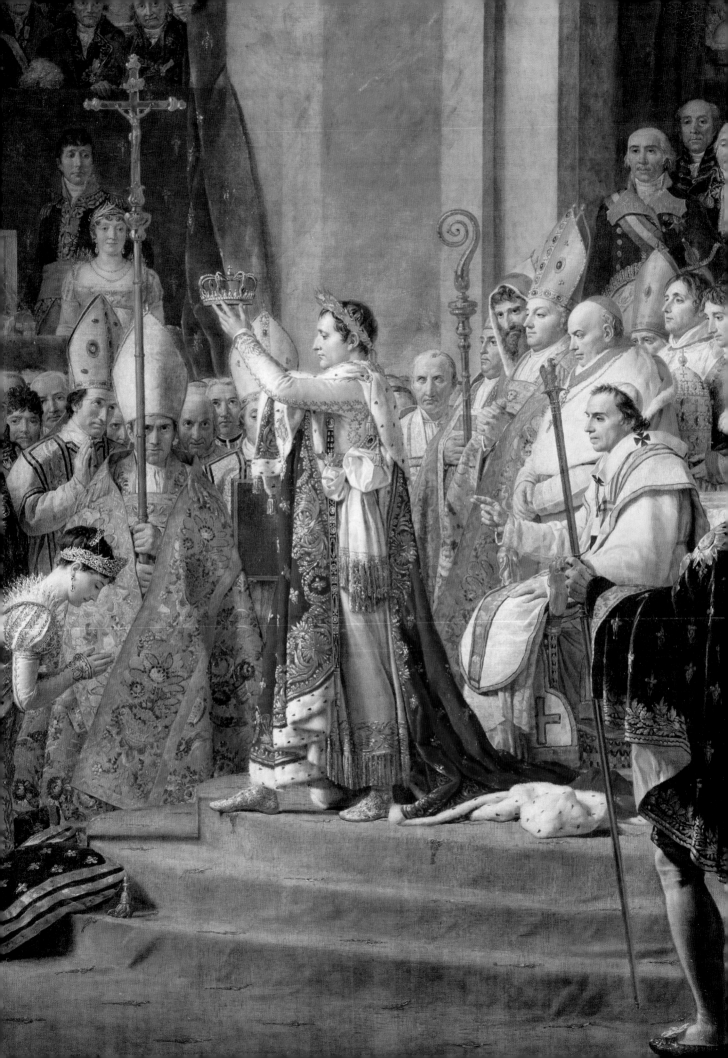

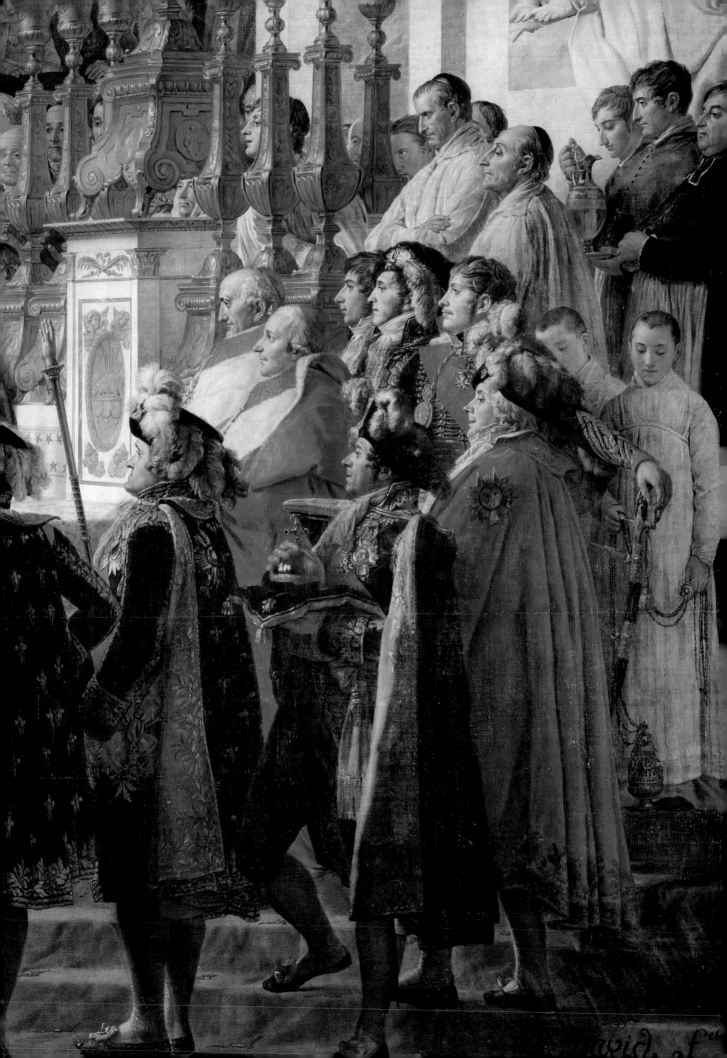

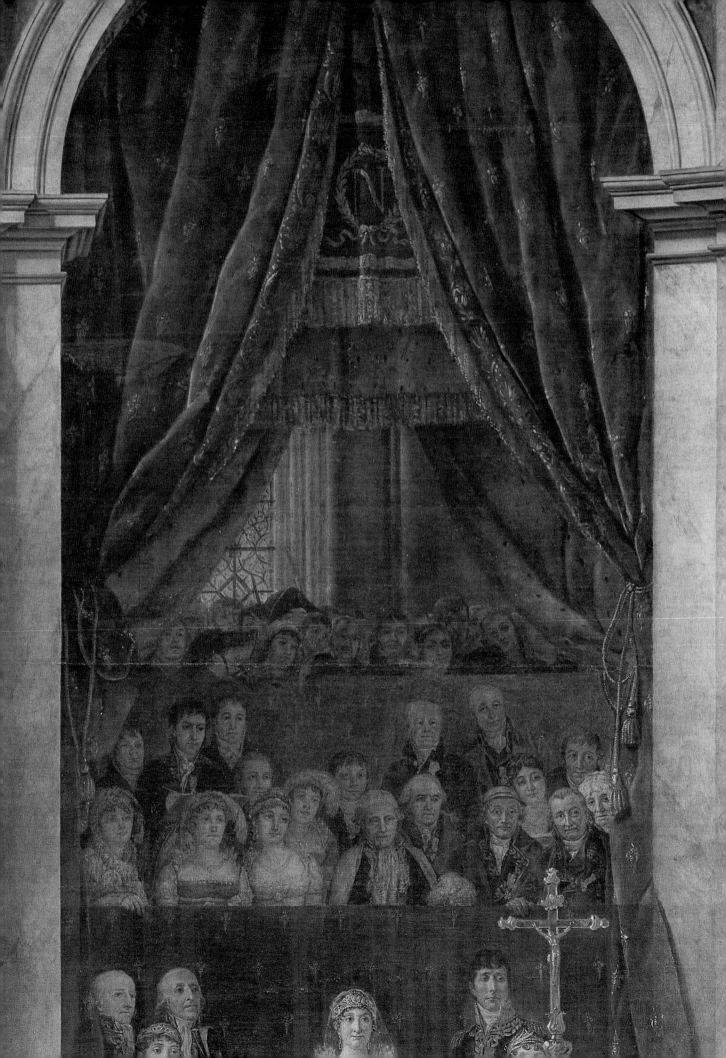

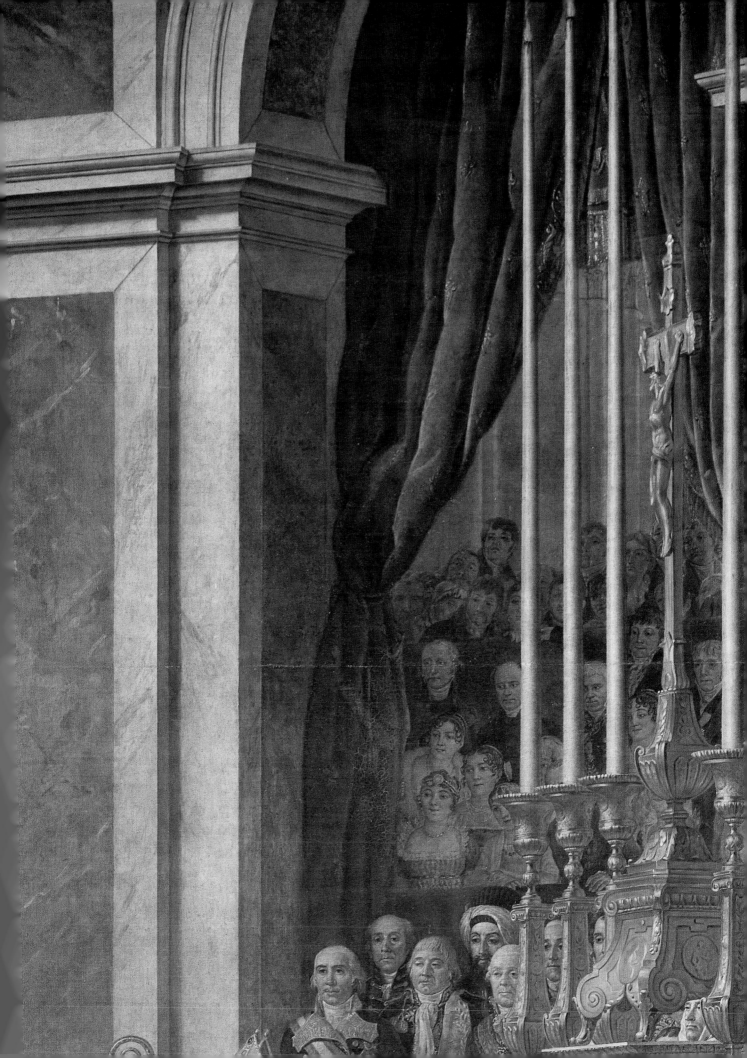

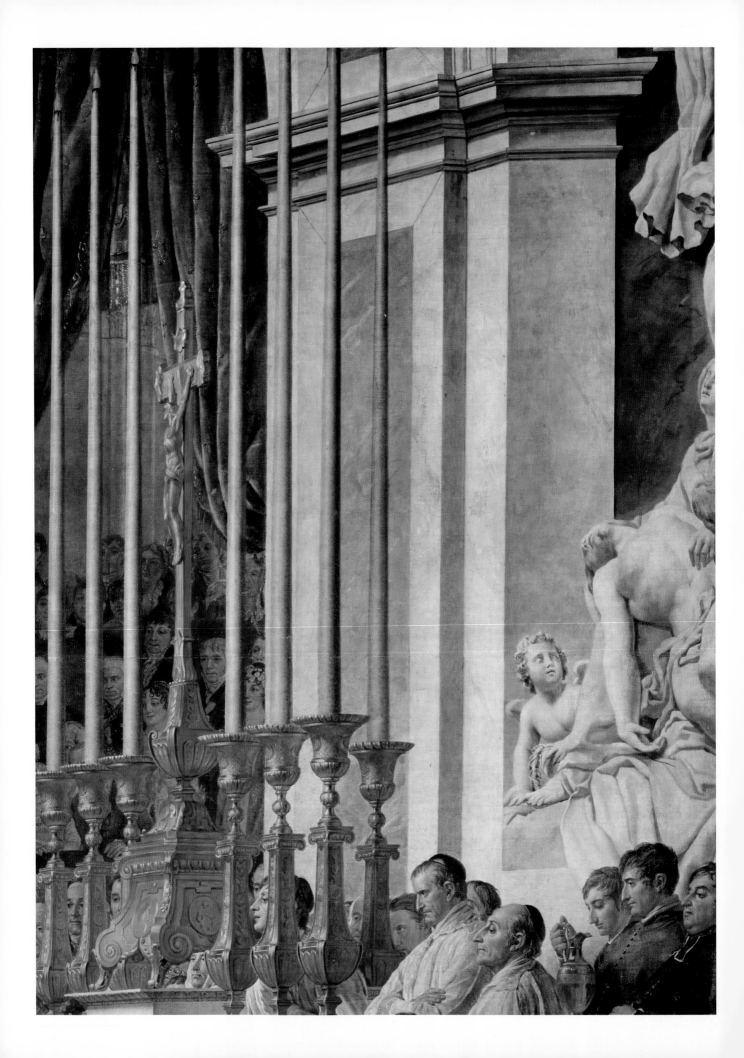

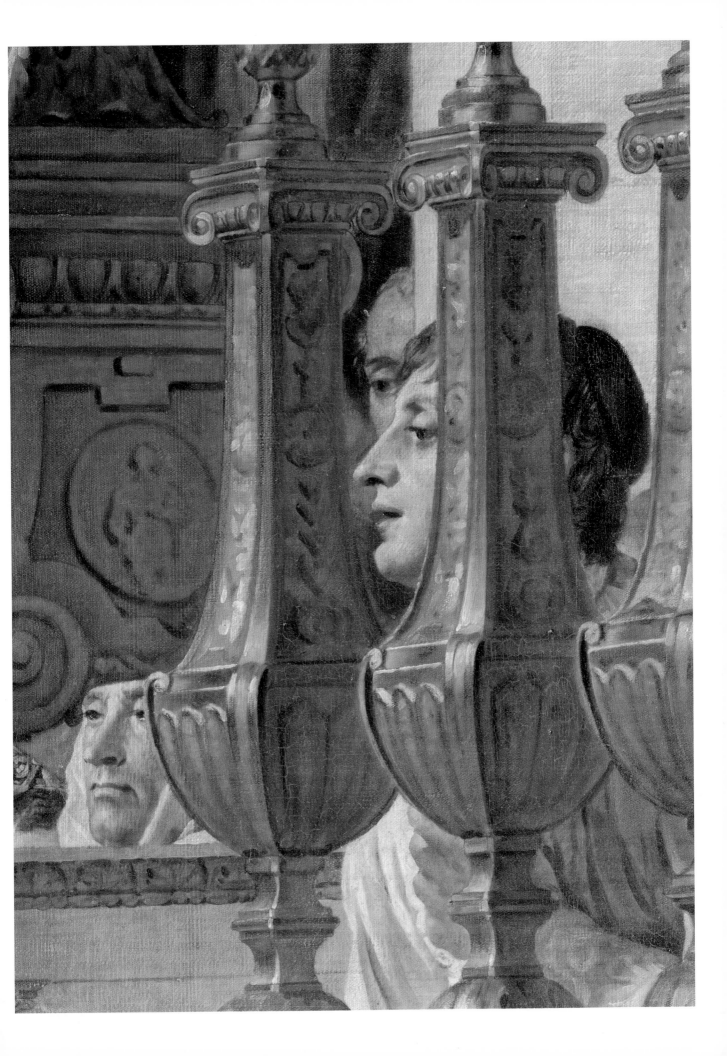

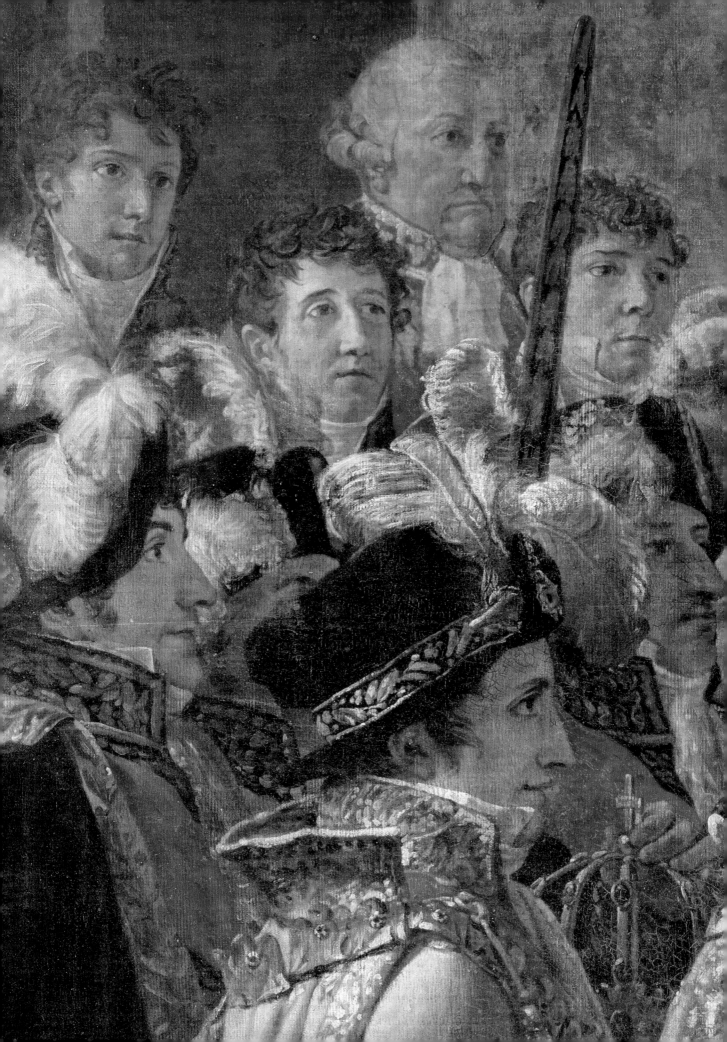

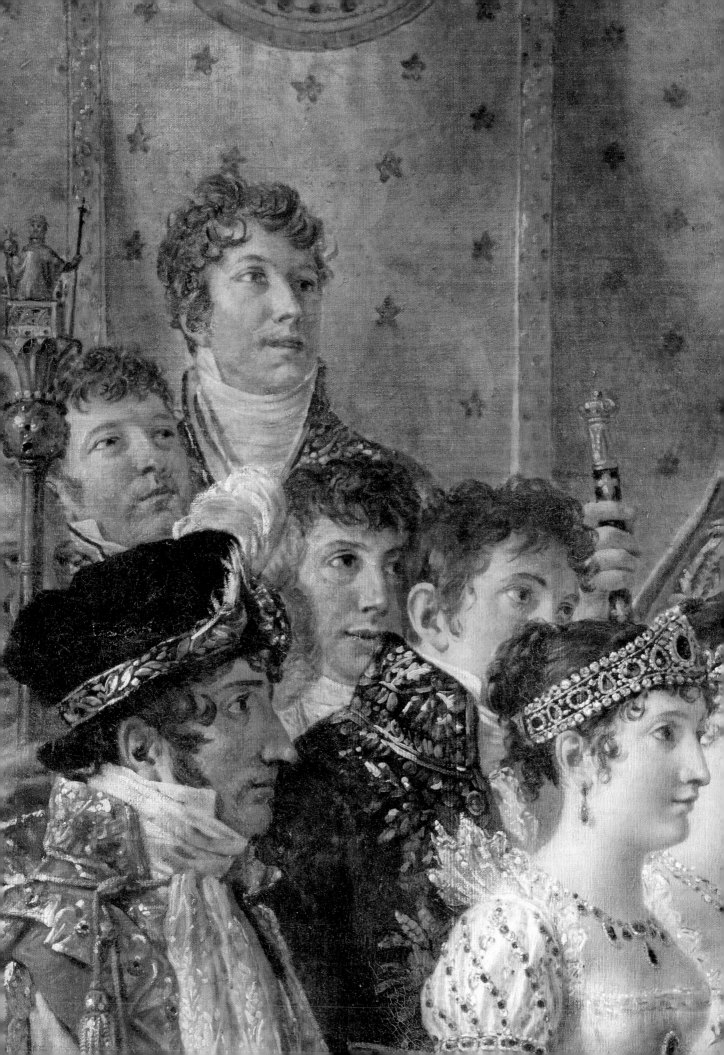

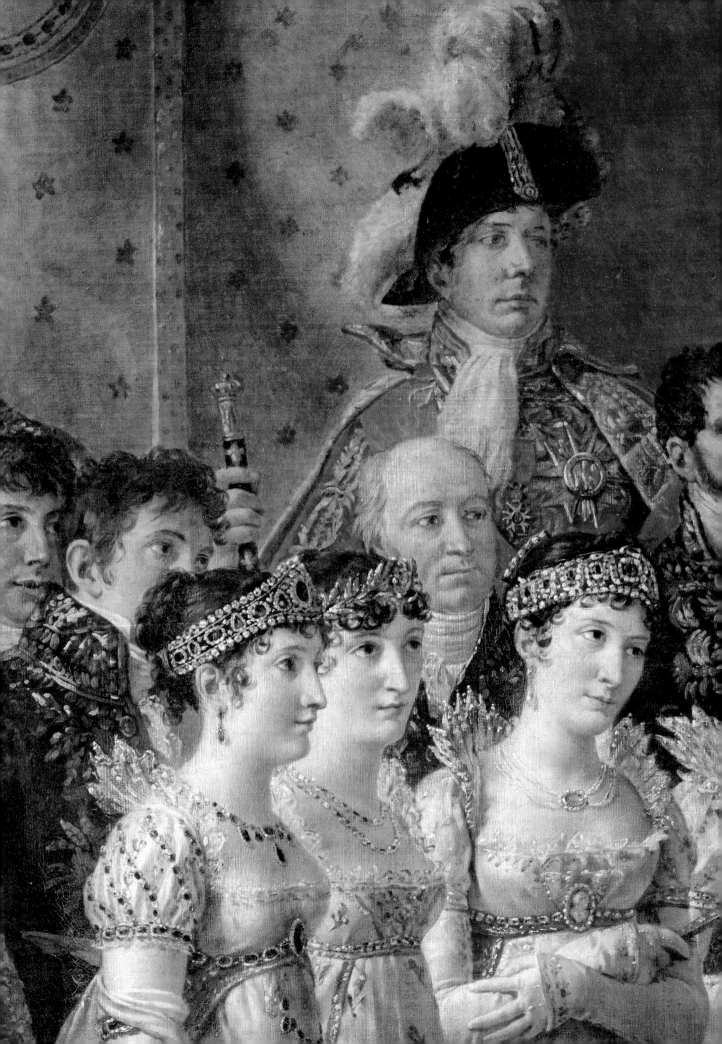

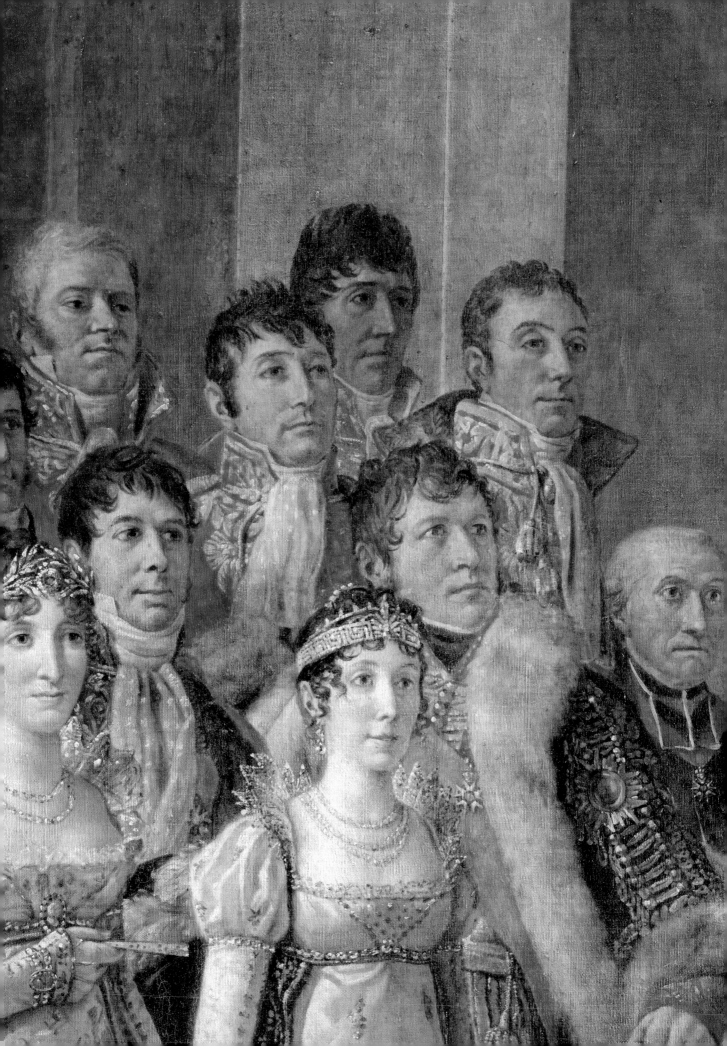

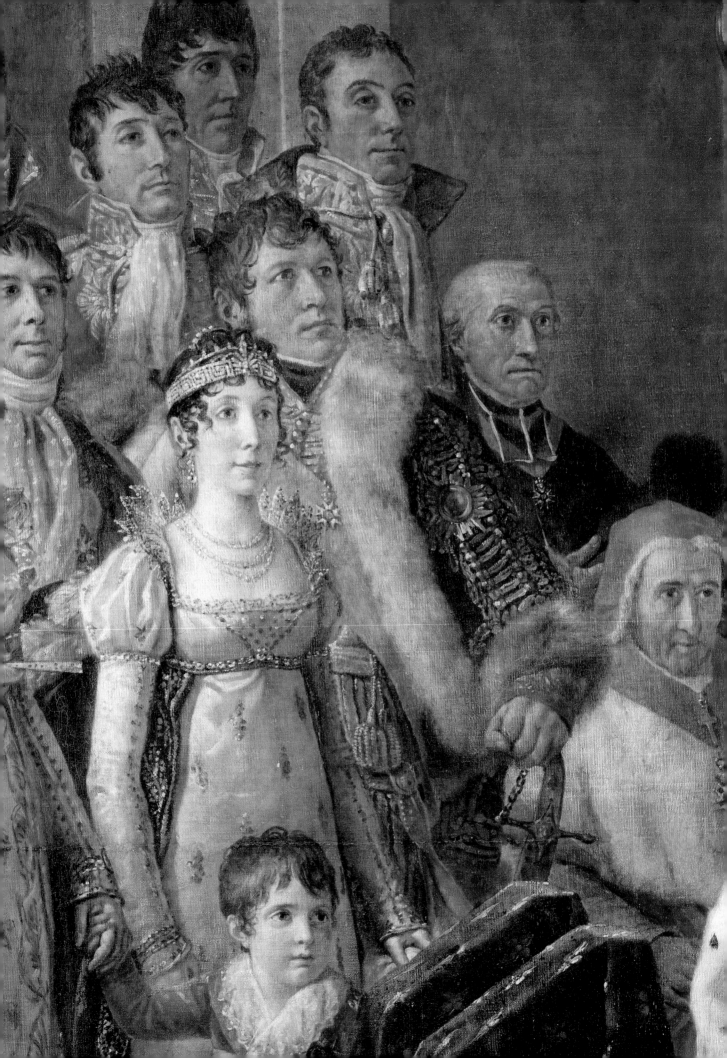

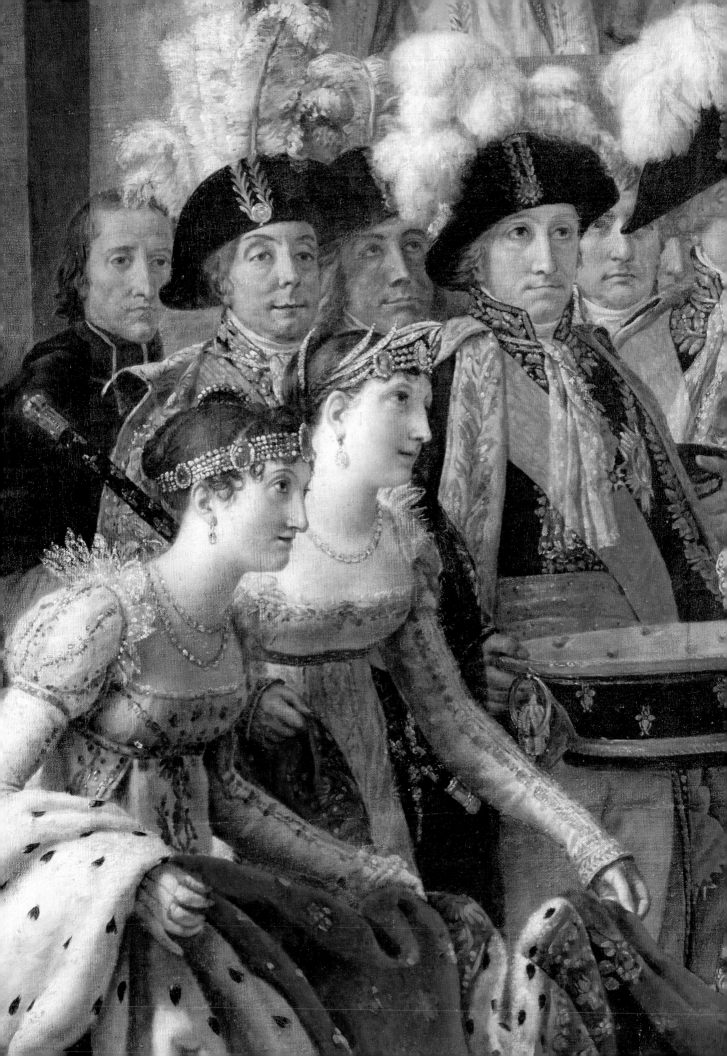

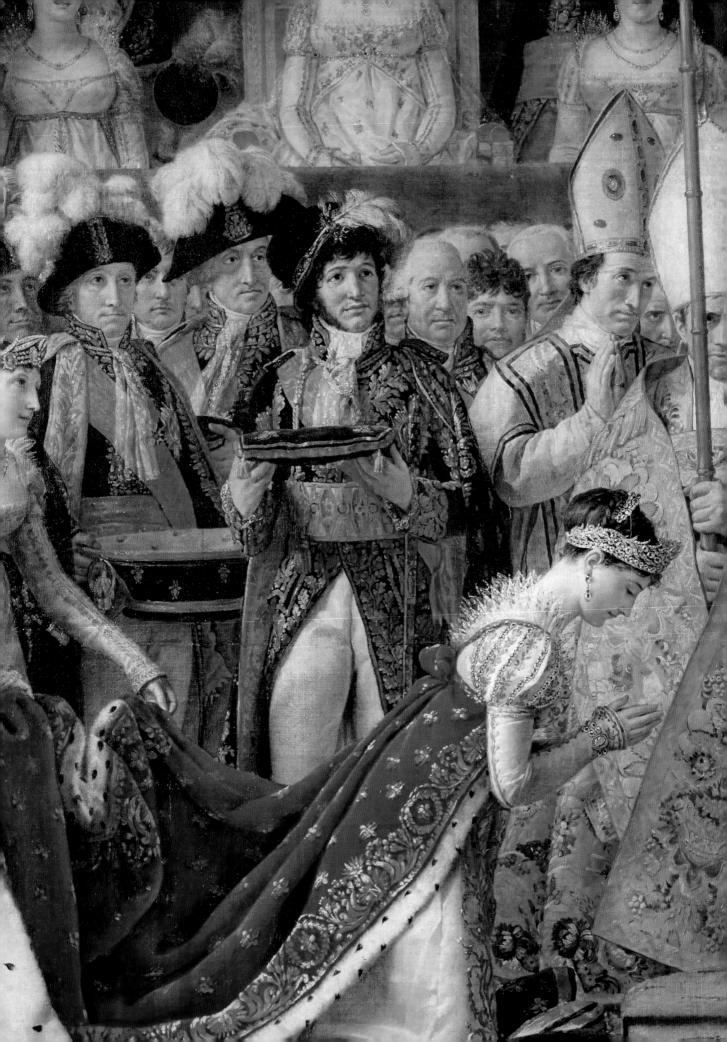

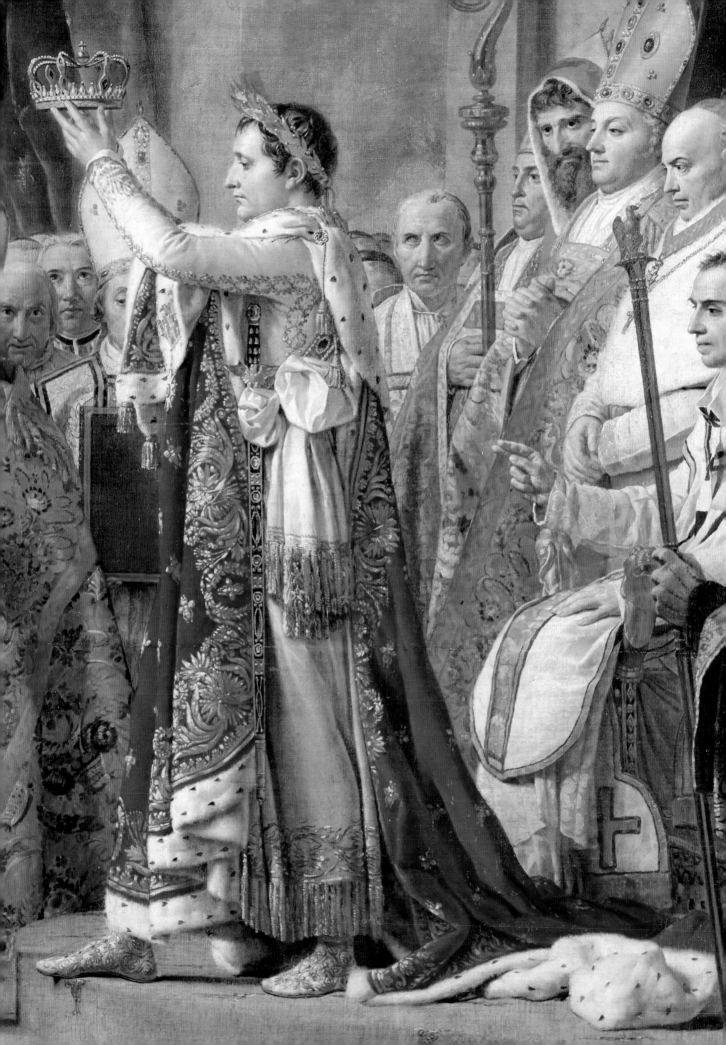

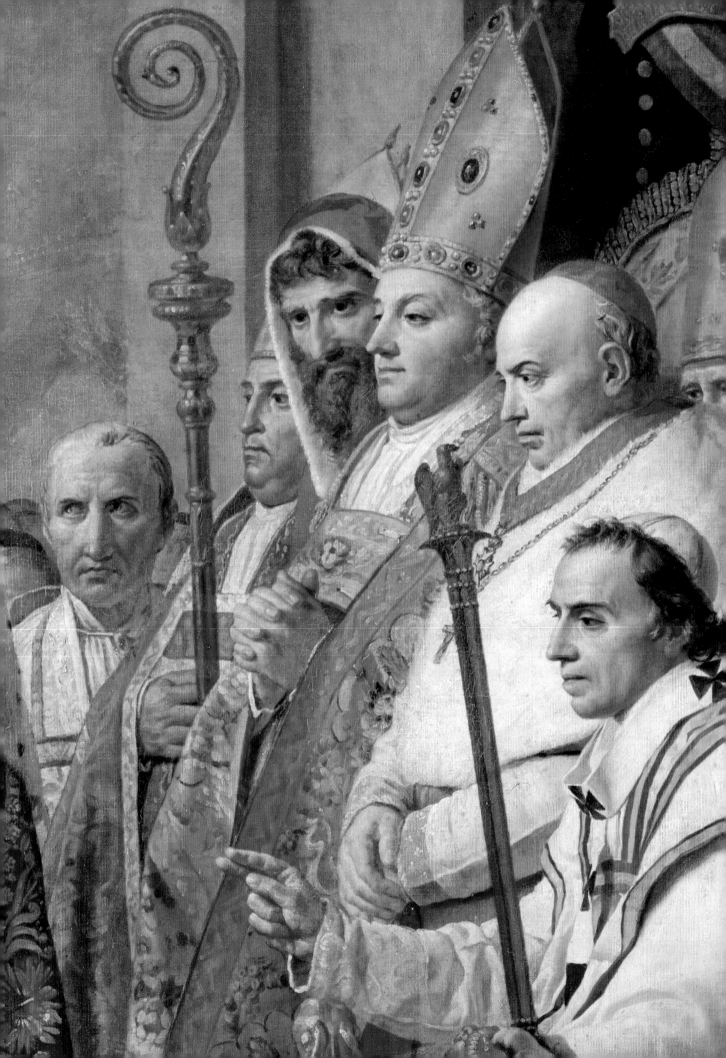

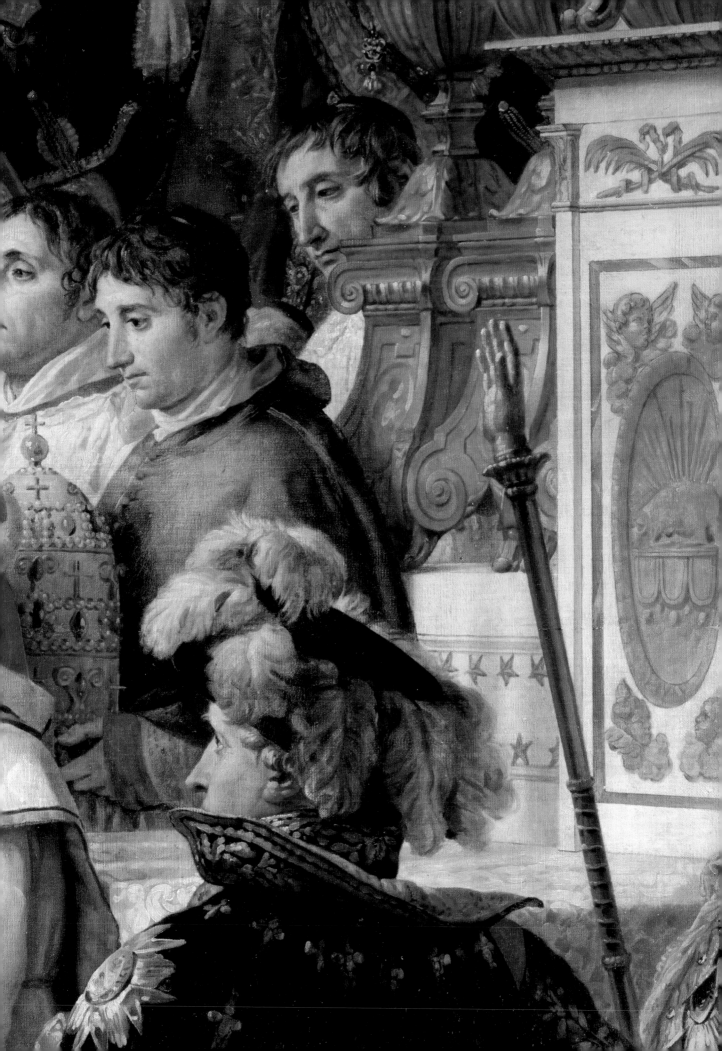

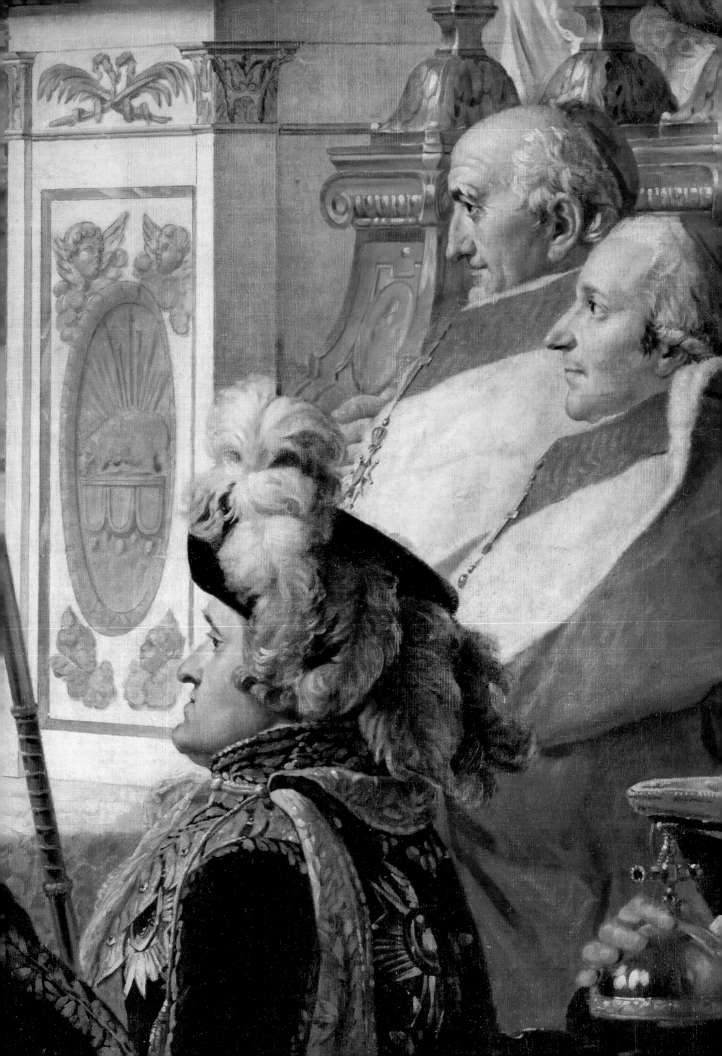

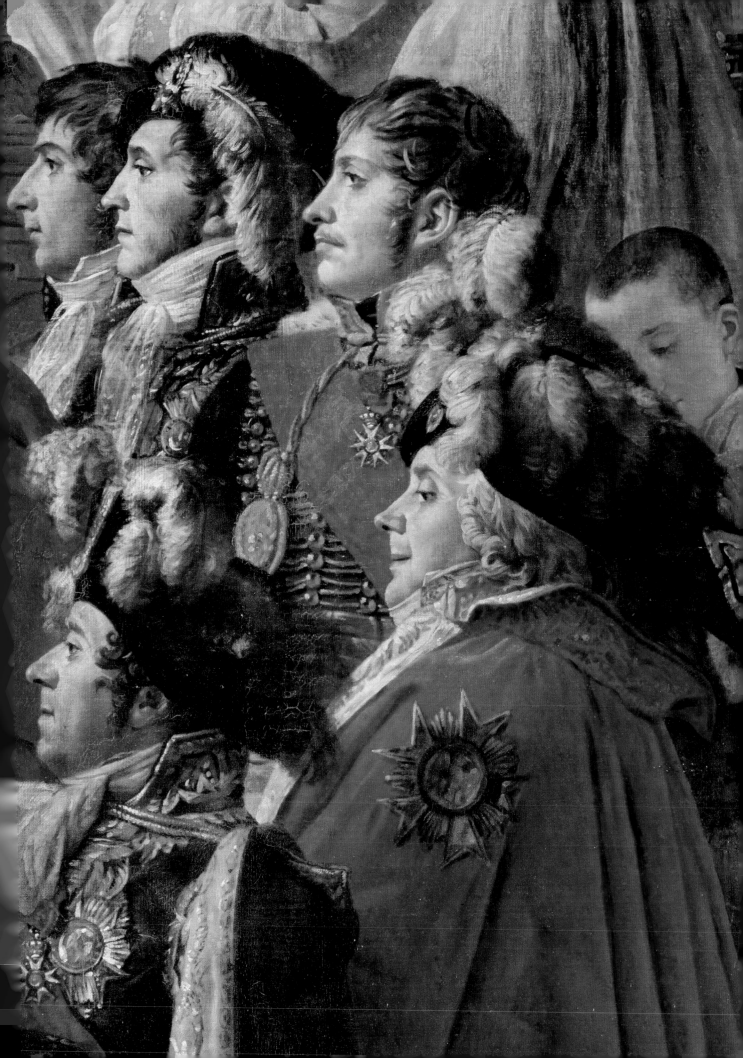

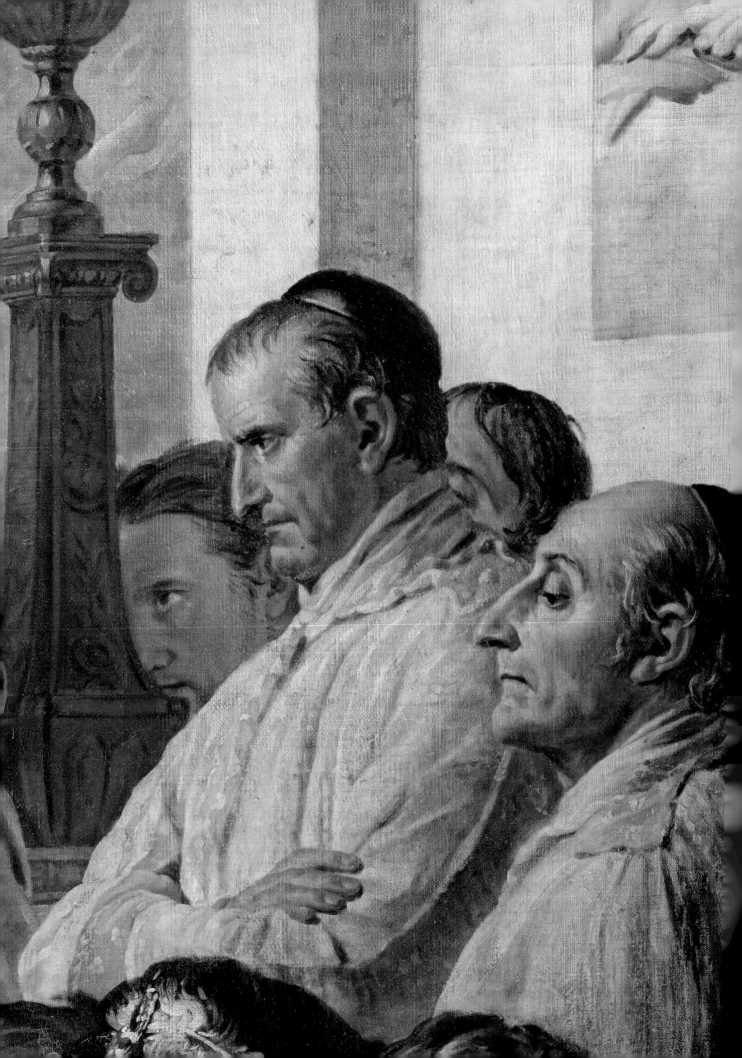

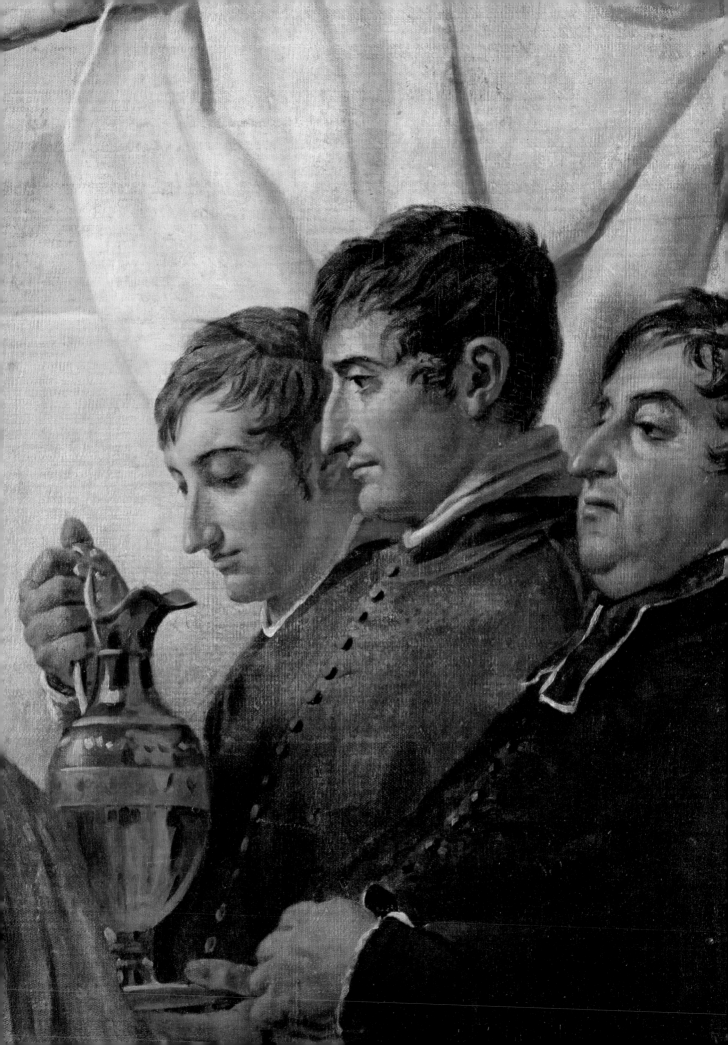

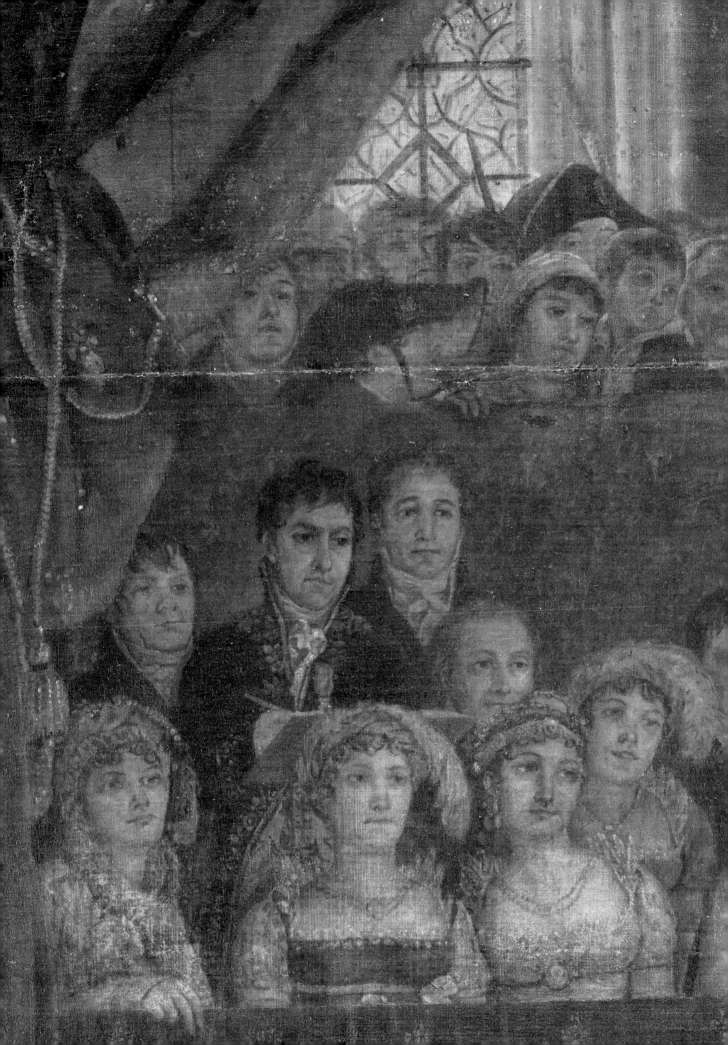

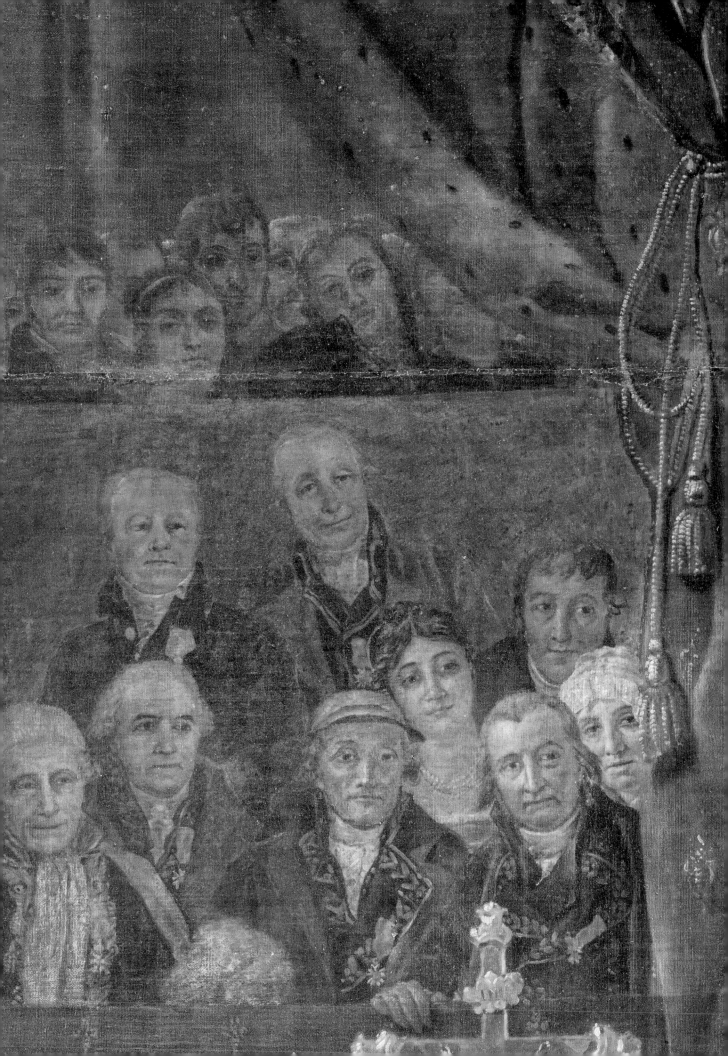

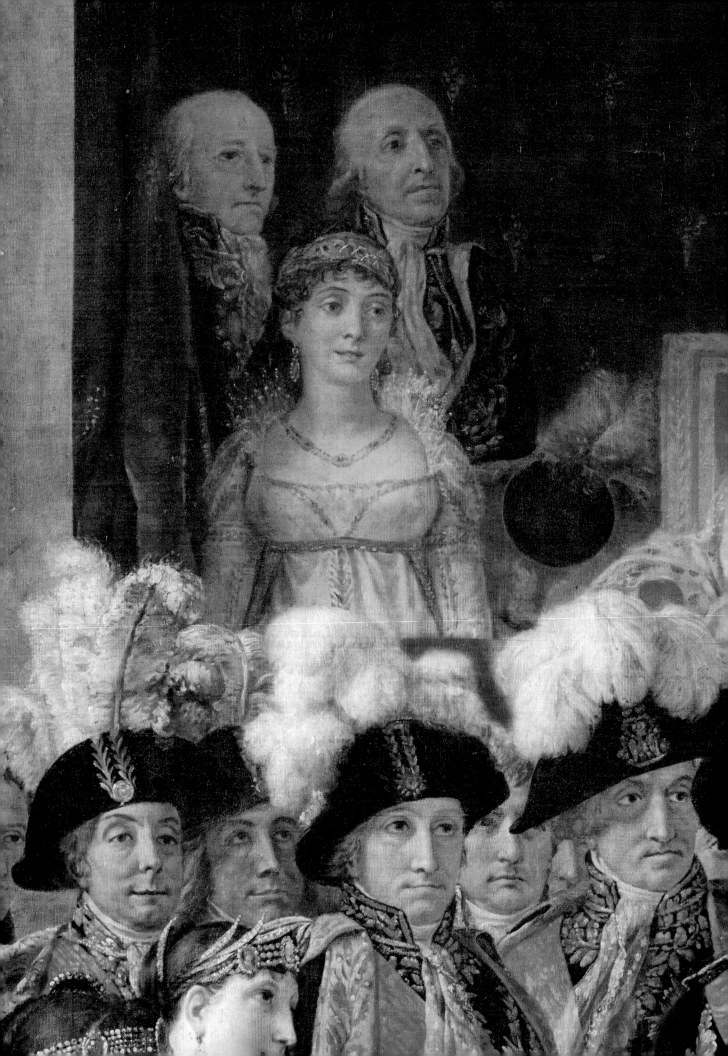

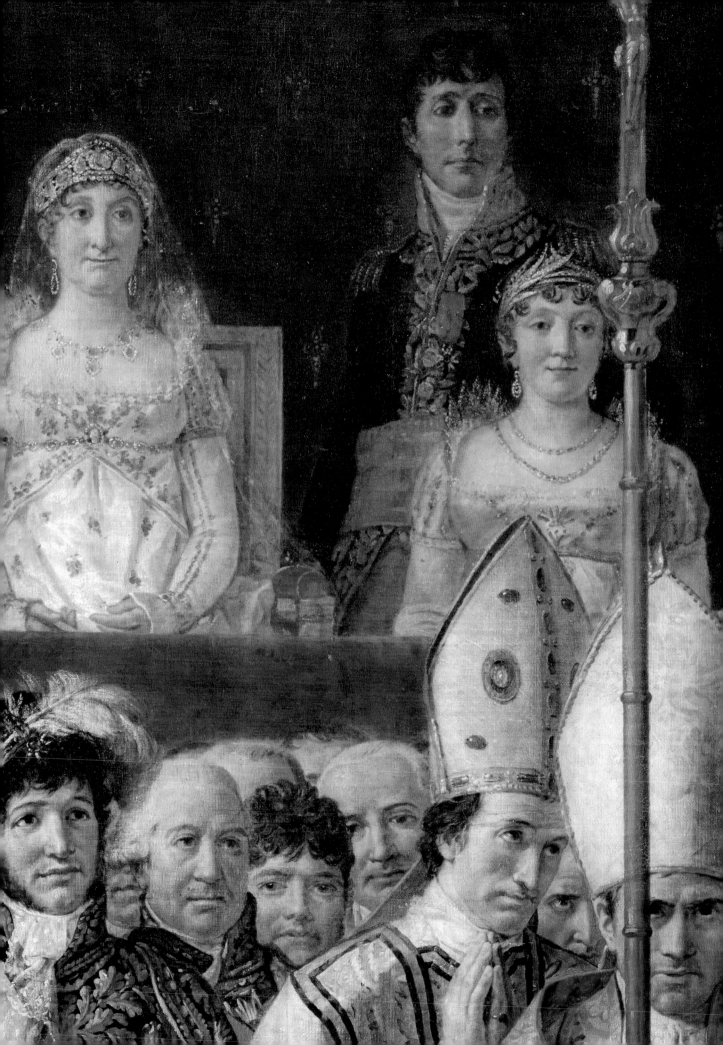

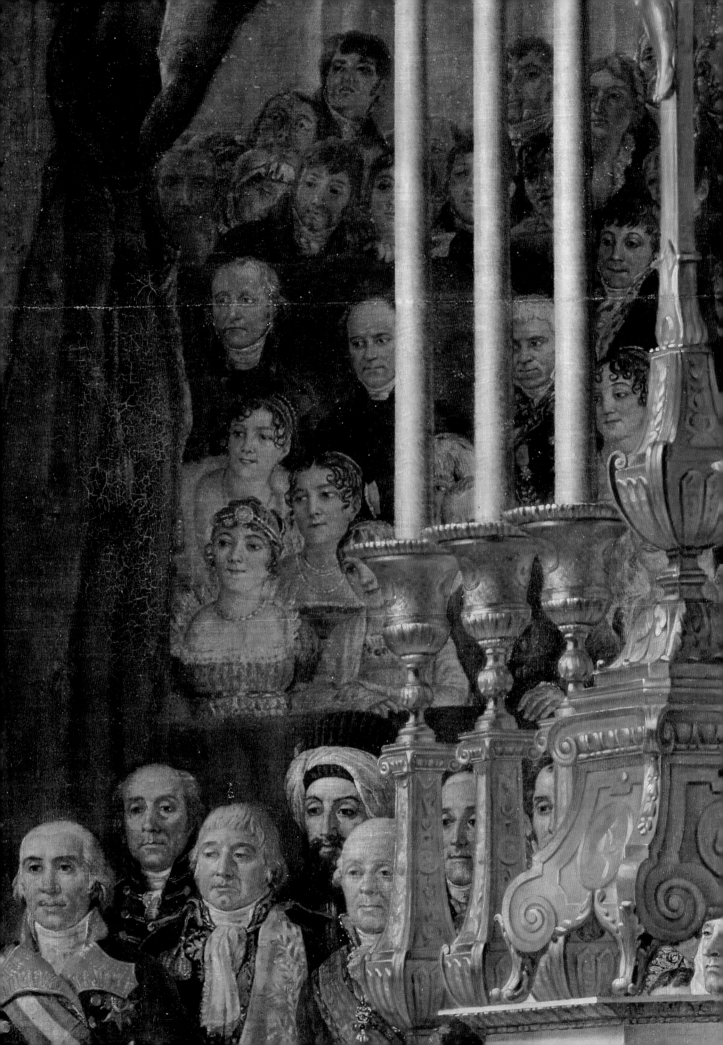

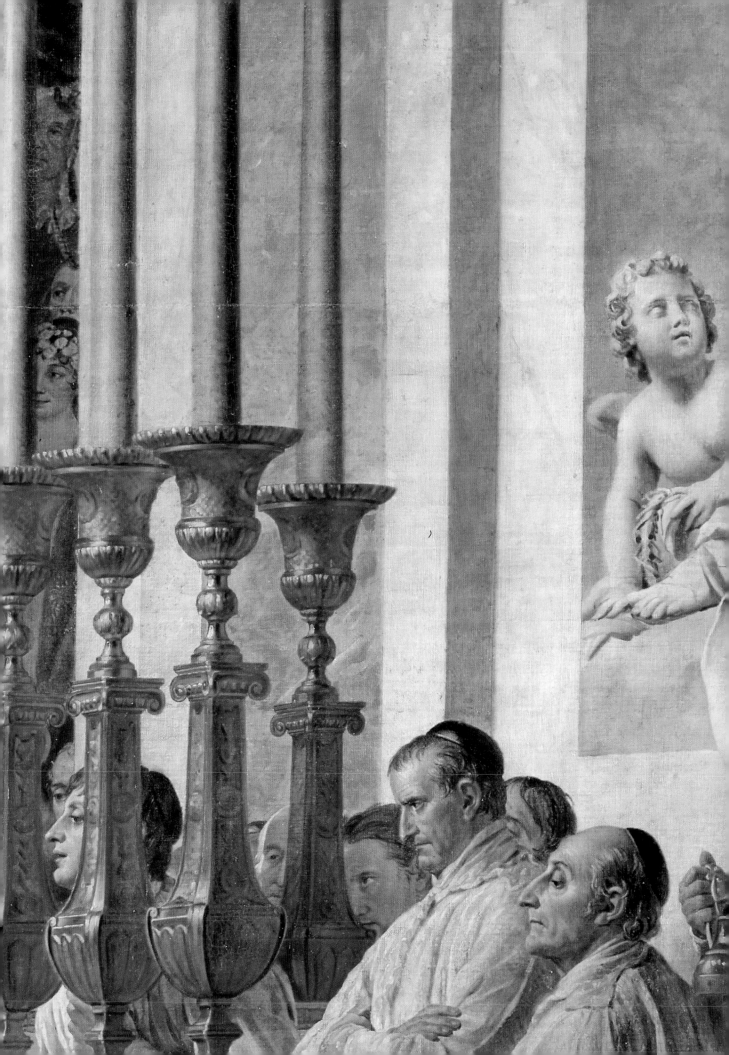

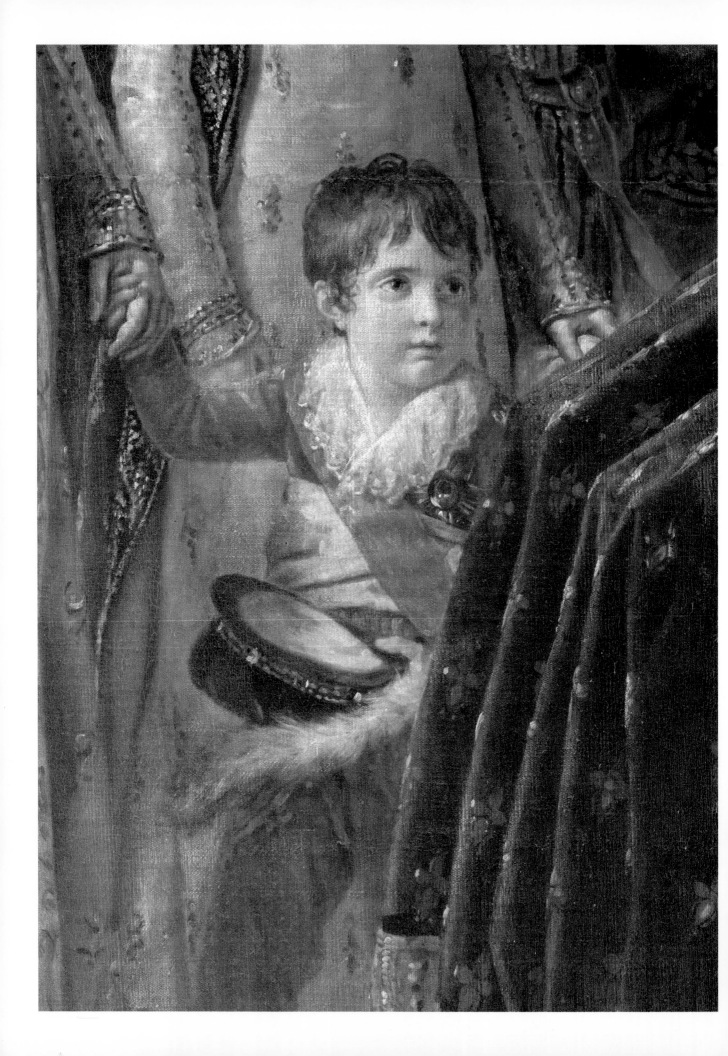

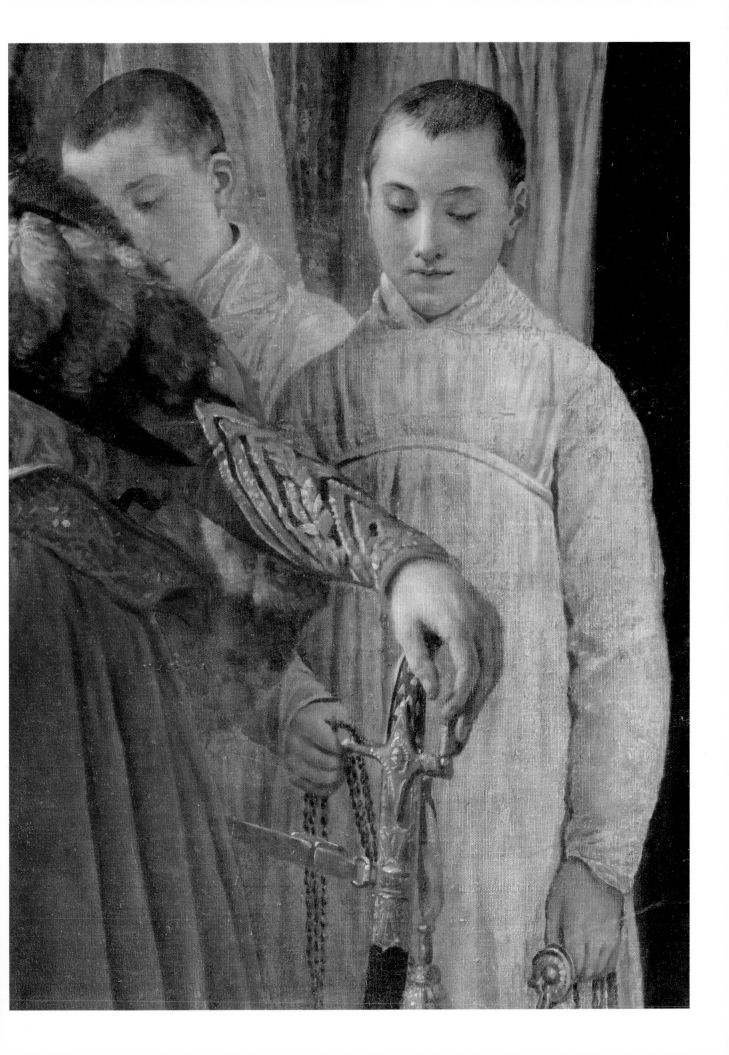